WORKING FOR
DIAGHILEV

EDITED BY
Sjeng Scheijen

WITH CONTRIBUTIONS BY
John E. Bowlt
Ada Raev
Sjeng Scheijen
Alexander Schouvaloff

GRONINGER MUSEUM

The Groninger Museum wishes to thank the following lenders to the exhibition:

State Tretiakov Gallery, Moscow

Victoria & Albert Museum/Theatre Museum, London
National Gallery of Australia, Canberra
Centre Georges Pompidou. Musée national d'art moderne/Centre de création industrielle, Paris
Musée Picasso, Paris
Collection Nikita and Nina Lobanov-Rostovsky, London
State Central Theatre Museum A.A. Bakhrushin, Moscow
State Museum for Theatre and Music, St Petersburg
The McNay Art Museum, San Antonio, Texas
Wadsworth Atheneum Museum of Art, Hartford, Connecticut
Musée des Arts décoratifs, Paris
Musée d'Art moderne et contemporain de Strasbourg
Thyssen-Bornemisza Collections
The Metropolitan Museum of Art, New York

CONTENTS

FOREWORD

The exhibition *Working for Diaghilev* is an outstanding example of what art can achieve when different disciplines come together. In combination with this book and the accompanying festival, the exhibition is more than just a tribute to the extraordinary figure of Sergei Diaghilev, whose passion sparked a fundamental renewal in the arts. His importance to Russia and to the influence of Russian art on the West was incalculable; Diaghilev was the driving force behind a revolutionary rebirth of dance in the late nineteenth and early twentieth centuries, and the discoverer and promoter of key Russian composers and choreographers like Stravinsky, Prokofiev, Nijinsky, Massine and Balanchine.

The exhibition clearly demonstrates that the artistic innovations instigated by Diaghilev were rooted in the Russian *fin de siècle*. Beginning in 1895, St Petersburg witnessed an unprecedented explosion of artistic activity, which was to have a huge impact on artistic developments in all of Europe's capitals. As this influence long went unnoticed or else was actively ignored, it is our duty not only to rediscover Diaghilev, but also to correct the standard image of him and to redefine the crucial place he occupied in European art. Russia has always stood on the frontier between the Western and Eastern worlds, and the many cultures to which it is home significantly influenced Diaghilev's productions. His great achievement was to transpose this distinctive Russian cultural atmosphere to Western Europe, enabling him to make an indelible mark on the renewal of dance, art and music. As the exhibition shows, the work of Bakst, Serov, Vrubel and Gontcharova has lost none of its eloquence; more than eighty years on, it is still able to entrance us.

The cooperation of Moscow's State Tretiakov Gallery – with which our institution has long enjoyed a warm professional relationship – has been vital to the exhibition's success. Always a pleasure to work with, the Tretiakov has been exceptionally generous with the number of loans it has allowed for this exhibition: over eighty of the works displayed come from the seemingly inexhaustible wealth of its collection.

Our gratitude is due to Vladimir Rodionov (Director) and especially to Lydia Iovleva (Deputy Director) for her extraordinary diligence and wise advice. We have also worked closely together with Evgenia Iliukhina and Irina Shumanova, curators of the Prints and Drawings Department, and with Galina Churak of the Painting Department. We thank all three for their professionalism and for their generous efforts on our behalf; they are shining examples of the substantive role that curators can play in our profession. Tatiana Gubanova, meanwhile, organized the Moscow end of the production with great enthusiasm and commitment.

The Victoria & Albert Museum in combination with the Theatre Museum in London was another major lender; the Groninger Museum is privileged to have received no fewer than fifteen Ballets Russes costumes from their magisterial collection. The Restoration Department worked hard for many months to ensure that the costumes could be displayed in optimum condition for *Working for Diaghilev* – a process that certainly would not have been possible without the special devotion of curator Sarah Woodcock, who acted as our adviser and whose efforts on behalf of the exhibition have been magnificent.

Key loans from Moscow and London are backed up with dozens of works from the National Gallery of Australia in Canberra and the Centre Pompidou and Musée Picasso in Paris. We are grateful to them for the immense confidence they have shown in our plans and for their willingness to make available works that are not ordinarily lent.

We have also been privileged to receive an exceptional loan from the private collection of Prince Nikita and Princess Nina Lobanov-Rostovsky, who for decades now have done Russian dramatic art the irreplaceable service of preserving thousands of art objects for posterity and encouraging scholarly research in this field. They have furnished us with a unique collection of work by Bakst, Gontcharova and Larionov, and Picasso, for which we are very much in their debt. What is more, Princess Nina Lobanov-Rostovsky deserves a special word of thanks for her immense commitment to this exhibition and the accompanying festival. We wish to extend our heartfelt thanks to all the other lenders.

Special thanks are also due to Patty Wageman and Sjeng Scheijen – both of them closely associated with the Groninger Museum as curator and guest curator, respectively. Patty Wageman has managed in exemplary fashion the organization of the exhibition, contacts with all the lenders and the production of this book. We are indebted, of course, to Sjeng Scheijen, curator of the exhibition and initiator of the overall Diaghilev project; it was during one of our many visits to Russia, where I was once again entranced by the work of Léon Bakst, that he suggested devoting an exhibition to Diaghilev to highlight the extraordinary importance of Russian art around the beginning of the twentieth century to the development of dance and art in Western Europe.

This catalogue, the exhibition and the festival are all intended to contribute to Sergei Diaghilev's dream of uniting the different artistic disciplines.

Kees van Twist
Director, Groninger Museum

WORKING FOR DIAGHILEV – AN INTRODUCTION

Ada Raev

Every period looks to the past for things that might help us better understand and deal with contemporary challenges. Little surprise then that a figure like Sergei Diaghilev, who caused such a furore across Europe around the turn of the twentieth century, should have re-entered our consciousness. Sergei Pavlovich Diaghilev (1872–1929) had many faces. His most outstanding qualities included an ability to spur artists, intellectuals and their patrons to cultural achievements that not only expressed the spirit of their own era and exerted their influence far beyond it, but also transcended the boundaries of genre, national origin and mentality. Hence historian Karl Schlögel's characterization of Diaghilev as 'the most important European to be produced by Russia in the twentieth century'.[1] Yet there is more to the exhibition *Working for Diaghilev* than a straightforward tribute to an extraordinary personality who by no means relished the idea of being placed in a museum.[2] It has also set itself the goal of perpetuating what Diaghilev – the tireless promoter who was content to appear a dandy (ill. 1) – understood from an early age to be his mission: to introduce the West to Russian art, which he viewed as an original and autonomous strand of European culture. He was to succeed brilliantly. Today's Europe once again faces the task of defining its diverse cultural identity, making *Working for Diaghilev* a combination of reconstruction and creation in a manner entirely fitting its subject.

It was a felicitous coincidence of personal qualities and interests on the one hand and historical conditions and opportunities on the other that made Sergei Diaghilev, the exhibition organizer, publisher, art critic and creator of the legendary Ballets Russes, a key figure in Russian and European culture in the early decades of the twentieth century. Diaghilev was born in Perm in the Urals, the son of a cultivated officer. In keeping with his social class and his father's wishes, Sergei went to St Petersburg in 1890

to study law at the university. At the same time, he attended the singing and composition classes held by Nikolai Sokolov (and not Rimsky-Korsakov, as is frequently claimed) at the city's conservatory. He recognized his strengths and weaknesses at an early age, as he confessed in a letter to his beloved stepmother, Elena Panaeva: 'First of all I am a great charlatan, albeit *con brio*; in the second place, I am a great charmer and in the third I am blessed with a great deal of cheek; fourthly I am a man with a pronounced capacity for logical thought, who is admittedly lacking in principles; in the fifth place, I am in no way possessed of any genuine talent. In spite of all that, I believe I have found my true vocation, which is to lead the life of a patron of the arts. I have everything one needs to that end except for money – *Mais ça viendra*.'[3] He was to be proved right.

Through his cousin Dmitri Filosofov, Diaghilev gained entry into an exclusive circle of young men belonging to the multinational intellectual élite of St Petersburg who, under the leadership of Alexandre Benois, championed an elaborate educational ideal. The same intimate and cultivated atmosphere is found in the mutual portraits of Konstantin Somov, Lev Rosenberg (known later as Léon Bakst), Alexandre Benois, Eugene Lanceray and Mstislav Dobuzhinsky, and was also to nourish the spirit and goals of the *Mir Iskusstva* – 'World of Art' – movement they subsequently created. The finishing touches to the young man's education and sophistication were provided by the obligatory trips abroad, during which Diaghilev met prominent contemporaries and bought his first works of art. His first move into the public arena took the form of exhibitions – organized in collaboration with his friends – of foreign and Russian artists, accompanied by critical and art-historical polemics. These ventures, which would have been impossible without Diaghilev's energy and assertiveness, culminated in the creation of the artists' society *Mir Iskusstva* and the magazine of the same name

(1898–1904), which served as a counterweight to established academic values and a Russian Realism by then in crisis. Viewed in retrospect, they basically embodied the Russian version of Modernism. The group's attitudes, conveyed in both words and images (ill. 2), were based on the universal quality of St Petersburg art and culture – especially that of the eighteenth and nineteenth centuries, which reflected Western European paradigms – and on the incorporation – directly attributable to Diaghilev – of a Moscow tradition that was renewing itself through the work of artists like Mikhail Vrubel, Valentin Serov, Konstantin Korovin, Isaak Levitan and Mikhail Nesterov. This disparate mix was held together by an all-embracing aestheticism embodying both melancholy and irony, the godparents of which were Friedrich Nietzsche, Oscar Wilde, Aubrey Beardsley and their eighteenth-century predecessors, in both art and literature. Diaghilev's eye for the totality and for overriding connections consistently enabled him to plan and achieve more ambitious ventures. He could act at times in competition to his more cautious friends, though his admiration for their qualities meant that he often involved them in his projects. His frequently attested openness and generosity underpinned a talent – extremely useful then, too – for winning over wealthy and influential patrons to his ideas and plans. Diaghilev's monograph on Dmitri Levitsky (ill. 3), whose work gave European stature to young, modern Russian portraiture, was to have been one of four volumes devoted to the history of Russian art. In the event, it was to remain a one-off; yet Diaghilev was to do pioneering work in this regard in a different medium.

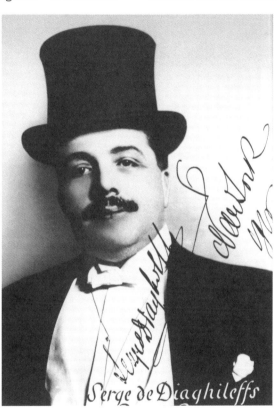

ILL. 1 DIAGHILEV IN NEW YORK, 1916.
BIBLIOTHÈQUE NATIONALE DE FRANCE, PARIS

In 1905 – the year of the First Revolution – he staged an exhibition of historical portraits at the Tauride Palace in St Petersburg, featuring more than 4,000 selected works. The show took place in the gigantic banqueting hall of the classical-style palace that Catherine the Great had once presented to her lover, Grigory Potemkin. It was transformed for the occasion into smaller, themed spaces using historical architectural features and leafy plants. Each was devoted to a particular monarch and the artists associated with him or her (ill. 4). In his speech at the opening banquet, which was later published in the journal *Vesy* [Scales] (1905, no. 4), the rather apolitical Diaghilev displayed an amazing empathy with the past. In the face of the magnificent portraits, the current occupants of the country's palaces seemed to him to be representatives of a social order no longer able 'to keep up the burden of parades past', while their uncultivated estates were an unmistakable sign of an approaching epochal shift, which he could envisage only as the birth of a new aesthetics. The relationship between cultural tradition and the need for constant aesthetic innovation was to occupy him until the end of his life, and was especially intensive and effective in his programme for the Ballets Russes. In 1906–07, Diaghilev presented his exhibition *Two Centuries of Russian Art* in Paris, Berlin and Venice. Alongside the section devoted to icon painting, it strongly emphasized the Western-influenced strand of modern Russian culture for the first time. The show was designed by Léon Bakst and was presented in Paris at the Salon d'Automne in a manner recalling the ambience of the portrait exhibition. In the sculpture room, for

ILL. 2 KONSTANTIN SOMOV, TITLE PAGE OF THE MAGAZINE
'MIR ISKUSSTVA', 1900

ILL. 3 TITLE PAGE OF 'RUSSIAN PAINTING OF THE EIGHTEENTH CENTURY.
VOL. 1. D.G. LEVITSKY 1753–1832. EDITED BY S.P. DIAGHILEV',
ST PETERSBURG, 1902

instance, he re-created a bower from the Petergof estate, to imbue the exhibition with the Petersburg spirit on both a large and a small scale; the effect was further heightened by the 'unusually large' section devoted to the 'World of Art'. Colourful wall-hangings in the individual rooms leading up to it also created a positive resonance, with their subtle allusions to the groups of works from different periods. The catalogue too contributed to the exhibition's immense success. The French version was written by Alexandre Benois, while the German was provided by Igor Grabar, who had belonged to the World of Art circle since his Munich period. In this way, Diaghilev fulfilled his long-standing dream of bringing the West face-to-face with Russian art.[4]

All the same, the concept of the exhibition came in for some criticism. Complaints were heard in both France and Germany, for instance, that nineteenth-century Realism in the shape of the *Peredvizhniki* [Wanderers] was all but absent, whereas it was precisely that movement – with Ilya Repin at its head – that had first drawn attention thirty years previously to what Rainer Maria Rilke had called that 'far-away land to the east'. It went largely unnoticed, by contrast, that Diaghilev also

included Symbolist and Neo-Impressionist work by younger artists like Sergei Sudeikin, Vasily and Nikolai Milioti, Mikhail Larionov and Natalia Gontcharova, despite the reservations of his fellow members of the World of Art. It was not to be the only occasion that Diaghilev refused to be put off by the prejudices of those around him when it came to getting his own, forward-looking way.

It was in the years running up to 1910 that Diaghilev embarked on the longest and most spectacular chapter in his career as artistic manager. It entailed a further, two-stage switch of profession. First of all, the positive reverberations of the 1906 exhibition of Russian painting inspired him to introduce Parisians to Russian music, too. The success of a series of concerts in May 1907, featuring works by Rimsky-Korsakov and Rachmaninov, led to a performance at the Paris Opera a year later of Mussorgsky's *Boris Godunov* with Feodor Chaliapin in the principal role. Through the set and costume designs of Alexander Golovin and Ivan Bilibin, the stylization characteristic of the World of Art group, which caught the mood of the period, was successfully transferred to the stage for the first time. Finally, 1909 was the year in which the Ballets Russes

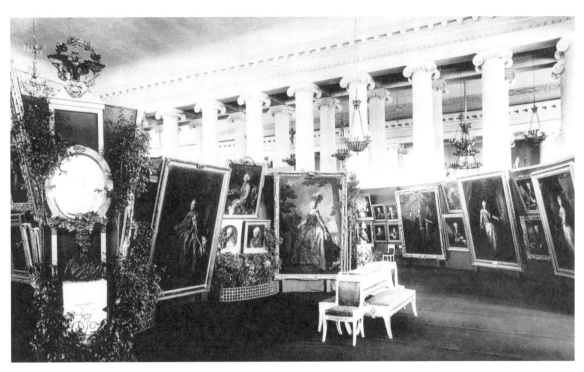

ILL. 4 'HISTORICAL ART EXHIBITION OF RUSSIAN PORTRAITS', TAURIDE PALACE, ST PETERSBURG, 1905

was created – the company that was to offer its innovations year after year for two decades, in spite of all the catastrophes and upheavals going on in the world.

From that moment on, Diaghilev was to operate on an international level, underpinned and legitimated by the experiences of the World of Art and Russian culture as a whole. As Alexandre Benois proudly put it at the end of the first of the 'Saisons russes' as they came to be called: 'We have shown the Parisians what theatre means.... Our journey here was plainly a historical necessity. We are that element within contemporary civilization, without which it would be doomed to decay.'[5] It was indeed their hitherto unseen character and successful synthesis of artistic disciplines that lent the Ballets Russes their special attraction. The German music and dance critic Oscar Bie wrote admiringly that 'the Russians do not differentiate between the arts in their performance. There is a consistent stylistic unity between sets, costumes, movements, rhythms and music. An exemplary awareness of artistic coherence governs every performance.'[6] The semantic and stylistic roots and components that shaped the Ballets Russes were many and diverse. They preserved the old Russian popular

tradition of the wandering player alongside the Western dramatic forms and heroes that supplanted them in the seventeenth and eighteenth centuries and whose cultivation had enabled the Russian court and nobility to validate their claim to belong to the Western world. This was particularly the case with the grand ballet tradition that was highly esteemed in Russia and which combined opulent display with sensuality and intense discipline. The Ballets Russes built on the revival in the Russian performing arts that began in the artists' colony at Abramtsevo under Savva Mamontov – patron of Viktor Vasnetsov and Mikhail Vrubel. They also drew heavily on the powerful element of theatricality and masquerade in the work of Alexandre Benois, Konstantin Somov, Valentin Serov, Alexander Golovin and other members of the World of Art, and on the high regard those same artists had for the idea, deriving from Richard Wagner, of the *Gesamtkunstwerk* or 'total work of art'.

The potential of ballet – by then perceived as a somewhat old-fashioned art form – had already been considered at an early stage within the World of Art circle. Walter Nouvel wrote to Konstantin Somov in May 1897: 'I believe that ballet has a

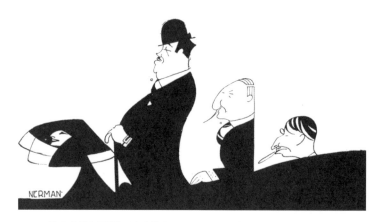

ILL. 5 'SOME CELEBS – AS SEEN BY NERMAN'. CARICATURE IN 'THE TATLER', 1922

great future, although not, obviously, in its present form.... Ballet needs a touch of the modern, to make it a vehicle for our delicate, refined and morbid feelings, emotions and forebodings. Most of all, it must be sensual; yet sensual in an aesthetic or, if you will, a symbolic sense.'[7] The artists in the World of Art group also shared the period's special interest in dance. There was a hope that, through this physical art form, the existential unity, the oneness of being felt to have been lost in the process of modernization could be regained.[8] It is hardly surprising, then, that Isadora Duncan's 1904 performances in St Petersburg should also have drawn the attention of the World of Art members. It was at this point too that Léon Bakst and Alexandre Benois received their first commissions to design theatre and ballet productions. Meanwhile, Diaghilev had been racking up experience as a special consultant to the Imperial Theatres in St Petersburg. So ardent was he in this role that he was dismissed in 1901 for exceeding his position and told he would never

be permitted to return, which partly explains why, in spite of their name, the Ballets Russes were never to perform in Russia itself.

Guided by Diaghilev's artistic intuition, charisma and iron hand, everyone involved contributed in their own way to the attraction of the Ballets Russes, a fact also attested by a number of intriguing cartoons (ill. 5). Musicians, librettists and choreographers transformed the evening-long narrative ballet into short performances, several of which could be shown in succession, in keeping with the modern taste for faster-moving intellectual stimulation. What linked these ballets was their highly sensual and erotic character, which now extended to the male dancers, too. Diaghilev's own, openly displayed homosexuality benefited this revolutionizing of the stage. Moreover, the androgynous gender images presented there also had an impact on society. Conventional ballet positions were modernized via a new vocabulary of movement conceived by the likes of Michel Fokine, Vaslav Nijinsky, Bronislava Nijinska, Léonide

ILL. 6 GEORGE BARBIER, NIJINSKY IN 'L'APRÈS-MIDI D'UN FAUNE', 1913

Massine and George Balanchine, which was put into brilliant practice by outstanding dancers like Anna Pavlova, Tamara Karsavina, Ida Rubinstein, Vaslav Nijinsky, Adolf Bolm, Serge Lifar and many others. Yet the public did not always understand these innovations; scandals were provoked, for instance, by Nijinsky's interpretation of the role of the faun in *L'Après-midi d'un faune* (ill. 6) and his choreography for *Le Sacre du printemps*. The involvement in the Ballets Russes of innovative composers – above all Igor Stravinsky – enabled ballet music to transform itself into a noteworthy musical genre. And it was artists, finally, from Alexandre Benois and Léon Bakst to Natalia Gontcharova and Mikhail Larionov, and ultimately Pablo Picasso, Naum Gabo and Giorgio De Chirico, whose set and costume designs were to guarantee the fascinating spectacle of the Ballets Russes. It was with a gaze fixed firmly on the past that the mid-twentieth-century art critic Hans Sedlmayr admiringly described the Ballets Russes as the 'swansong of fine art'. He might equally have been speaking of the legacy of the World of Art.[9]

ILL. 7 SERGE LIFAR AT DIAGHILEV'S TOMB IN VENICE

The repertoire of the Ballets Russes, which Sergei Diaghilev brought to the stages of Europe and America in the course of a quarter of a century, embraced all the different layers and components of Russian culture: its old-Slavic and Russian Orthodox roots; its classical-oriental elements; the French baroque and rococo that were held in such high esteem in the culture of St Petersburg; the German romantic tradition; and the constructivist experiments of the early Soviet Union. By integrating them in their overall European context between Christianity (*La Légende de Joseph*) and more modern, metropolitan culture (*Les Biches*), he offered the rest of Europe the opportunity to look at itself as if both in a mirror and via a journey through history. He was also sufficiently resolute to draw on avant-garde impulses from different quarters, even if this went against the convictions of other members of his movement. This is evident in ballets like *Le Coq d'or* (1914), *Parade* (1917) and *Les Noces* (1923), not to mention *La Chatte* (1927) and *Le Pas d'acier* (1927). To the end of his life, moreover, he never ceased to honour the cult of the beautiful, which he saw as the essential linking factor and which he traced back to its classical origins in *Apollon Musagète* (1928). It was an ethos that he imparted to all his collaborators, lovers, audience and, ultimately, to those born much later.

Sergei Diaghilev, the prototype of the modern art manager, died and was buried in Venice (ill. 7) – the city against which his creative birthplace of St Petersburg, the 'Venice of the North', always sought to measure itself.

Diaghilev's work created a more appropriate standard by which to do so – one that this exhibition seeks to help restore for both our own time and the future.

DIAGHILEV AND THE VISUAL ARTS

Sjeng Scheijen

How may we best sum up Diaghilev's artistic identity? The labels customarily attached to him – those of impresario and patron[1] – fail to do justice to the powerful influence he exerted on the arts in the early part of the twentieth century. His goal of developing his own variant of the Wagnerian *Gesamtkunstwerk*, without ever really producing creative work of his own, makes it difficult to place him or to assess the value of his achievements. Was he the prototype of the contemporary conceptual artist or of the artist as businessman? Or was he first and foremost a showman, a skilled organizer, though one with genuine flair and taste: an up-market P. T. Barnum or Irving Thalberg? We might come a step closer to Diaghilev's true artistic nature by applying a hierarchy to the different artistic fields in which he was active. Which of the arts did Diaghilev influence most strongly?

Music was undoubtedly his first and greatest love. His parental home in Perm witnessed performances that were both fanatical and inspired, not least by professional singers and musicians like Mussorgsky, who were invited to elevate the family's musical *soirées* and to instruct the children. Diaghilev's substantial musical talent was nurtured by this highly stimulating setting. The only occasions on which he sought to become a creative or performing artist were in the field of music, even though his talent was ultimately to prove insufficient: his singing voice was not good enough for a career at the opera and he was rebuffed when he sought to enrol as a student of composition under Rimsky-Korsakov. Nevertheless, Diaghilev's influence on musical culture has been of lasting importance. It was he who discovered Stravinsky and Prokofiev and who introduced Western audiences to the music of Glinka, Borodin and Mussorgsky – another respect in which he wrote and rewrote the artistic history of Europe. Ultimately, however, Diaghilev's most visible legacy and influence are to be found in a world that only began to fascinate him at a relatively late stage – that of dance. It was not until shortly before 1900 that Diaghilev was finally gripped by the world of classical ballet, although many more years were to pass before he realized that he himself had a role to play in it. It is frequently noted that it was financial necessity that pushed Diaghilev into ballet; he would have preferred opera, but was afraid he would not be able to assemble the funds needed to maintain a profitable opera company. Yet ballet was to be the only branch of the arts of which it can be firmly asserted that without him it would have looked very different and might not even have survived. Diaghilev introduced the short, half-hour ballet, provided a revolutionary stimulus to the development of choreography by constantly demanding innovation, and persuaded established, grand repertoire composers to write for the ballet.

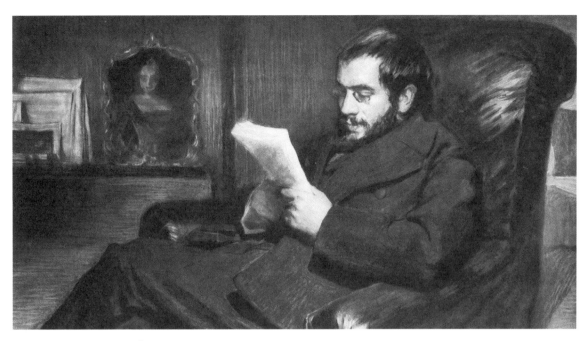

ILL. 8 LÉON BAKST, PORTRAIT OF ALEXANDRE BENOIS, 1898. STATE RUSSIAN MUSEUM, ST PETERSBURG

Ballet music had hitherto been produced almost exclusively by specialist dance composers, whose status was very similar to that of today's composers of movie scores. It is solely thanks to Diaghilev that ballet today still occupies a prestigious place among the arts – an achievement unmatched by anyone else in any other branch of creative expression.

In other words, the standard characterization of Diaghilev as primarily a man of the stage – dance and music – is logical, readily supported and not, therefore, open to dispute.

Yet it is precisely that certainty as to Diaghilev's key artistic legacy that makes it so important for us to realize that his *Lehrjahre* – the first seven years of his public career – were actually devoted to the very different muse of fine art. More than that, the vast majority of his serious writings were devoted to painting. Virtually all his critical articles and his only larger-scale work – a monograph on the eighteenth-century portraitist Levitsky – were written before he turned his gaze once and for all towards the theatre.

Anyone who wishes to form an accurate picture of Diaghilev's artistic identity is obliged to explore and analyse his involvement with art, the importance of which is further heightened by the fact that he wrote virtually no serious articles after 1907 from which we can glean anything about his artistic choices. However incomplete, Diaghilev's

critical writing on the subject of art represents the foremost source of information about his artistic mentality.

First Steps. Relationship with Alexandre Benois
Diaghilev's most important achievements in his exploration of the visual arts began in 1898 with the founding of *Mir Iskusstva* [The World of Art] – virtually the only and certainly the most important art periodical in Russia at the time. He continued to produce the magazine until its disappearance in 1904, the year in which he organized his first major exhibition, devoted to Russian and Finnish artists. Exhibitions also followed under the World of Art banner. The Levitsky monograph was published in 1902. In 1905 Diaghilev organized a revolutionary exhibition of Russian portrait painters at St Petersburg's Tauride Palace, featuring over 4,000 portraits brought together from all over Russia and including several works from the seventeenth century. He mounted his first Paris show in 1906: an exhibition of modern Russian art that marked his move to the French capital and the end of his active involvement in art. Up to 1906 he staged a total of sixteen exhibitions.[2] There is considerable uncertainty regarding the years between Diaghilev's arrival in St Petersburg in 1890 and the launch of *Mir Iskusstva*. What did his formative years look like? When Sergei Diaghilev arrived as a student in

St Petersburg, he joined the circle of friends of his cousin Dima (Dmitri) Filosofov, which comprised a group of highly educated arts fanatics who wrote, drew, painted and played music together. Alexandre Benois (ill. 8) was a key member of the group and very much its intellectual leader. Benois – who in addition to being a painter was a theatrical designer and above all an art critic – still enjoys a very high reputation in his native country, where he is considered one of the most important historians of Russian art. Much has always been made of the notion that when Diaghilev first arrived in St Petersburg, his friends tended to view him as a rough diamond, in need of guidance and education. Benois is said to have acted as Diaghilev's mentor in that period, certainly when it came to art, but it is highly questionable whether this is a fair representation of the facts. The information on which it is based comes largely from Benois' own autobiographical writings, which he did not commit to paper until the 1930s – long after Diaghilev's death – by which time it was very much in the author's interests to burnish his reputation by stressing his own alleged influence on what had, in the meantime, become a world-famous figure. Benois' account has

ILL. 9 JOZEF ISRAËLS, C. 1881. RIJKSDIENST VOOR KUNSTHISTORISCHE DOCUMENTATIE, THE HAGUE

often been accepted uncritically, exaggerating at the very least the role he played in Diaghilev's development. Orlando Figes even claimed recently that Benois and Diaghilev had founded the Ballets Russes together – an assertion for which there is not a shred of historical evidence.[3]
The reality appears to have been more complex. It certainly looks as though Benois – and possibly others too (Walter Nouvel and Konstantin Somov) – was keen to act as mentor, but that Diaghilev was not a person to be moulded easily. The friendship between the two men, which was to last until the end of his life, meant a great deal to Diaghilev,

especially in those early years; yet it is equally plain that Benois' paternalistic attitude towards his younger friend was a significant source of tension in the early part of their relationship. We can be sure that Diaghilev did not readily accede to Benois' authority. In fact, the whole of their early correspondence shows that Diaghilev was keen to shrug off Benois' self-imposed mentorship. Benois' memoirs are therefore a wholly unreliable source when it comes to an accurate description of his relationship with Diaghilev. In reality, these two very different characters appear to have been linked by a friendship that was both genuine and strategic.
Although Diaghilev's very first article was supportive of Benois, stating that Tretiakov had purchased one of his works, it also struck a critical note where it said that the exhibition was 'not entirely successful' and that Benois' works lost 'some of their power' in it.[4] He described the painting bought by Tretiakov as 'curious'.[5] This evidence is at odds with Benois' later claim that Diaghilev's earliest articles were produced with his full collaboration and even that he edited them.[6]
Mir Iskusstva was founded in 1898 in a manner suggestive of a minor coup d'état within the group of friends. Diaghilev seized on a moment when Benois was on an extended trip abroad to put their long-standing idea of creating a magazine into practice. He consulted Benois by post, but did not offer him a substantial role. Even the title that Benois had come up with for the magazine – Vozrozhdeniye [Renaissance] – was cast aside. All the same, Diaghilev demanded in his familiar and assertive tone that Benois provide at least five articles a year for the publication. Benois appears to have hesitated at first, but he expressed his cautious support for Mir Iskusstva in letters to Filosofov and Nouvel, although he also wrote that the magazine had come into being

under pressure (*forcément*) and he missed few opportunities to play down its importance ('when did Michelangelo ever have need of a magazine?'[7]). In spite of all this, Solomon Volkov, in his celebrated *St Petersburg, a Cultural History*, writes of Benois that *Mir Iskusstva* was '*his* magazine'.[8] The correspondence between Diaghilev and Benois displays a clear tension in the years around the creation of *Mir Iskusstva*. Benois continued to patronize Diaghilev and to criticize his plans and ideas, and may have felt frustrated as his supposed protégé swiftly came to occupy the leading position in their mutual circle of friends, for Diaghilev's stock quickly rose in Petersburg's artistic community.

First Articles

In addition to his work as organizer and editor, Diaghilev wrote numerous critical articles in the years after 1896, most of them devoted to fine art. While the tone of his earliest articles may not be very firm and the judgements and opinions he proffered rather inconsistent, several features of his style and approach are immediately apparent: a tendency towards polemic, a colourful and unexpected use of vocabulary, and propaganda on behalf of his artistic cronies that was

ILL. 10 ILYA REPIN, PORTRAIT OF VLADIMIR STASOV, 1883.
STATE RUSSIAN MUSEUM, ST PETERSBURG

at times shameless. Diaghilev began to champion his artist-friends in his very first article – an anonymous review of an exhibition of watercolours; in it, he informed the organizers that they had been mistaken in omitting the then entirely unknown Lev (later to be known as Léon) Bakst, while also letting drop that Pavel Tretiakov – the most visible and active collector of modern art at the time – had recently bought a piece by the young artist Alexandre Benois. He also focused on several foreign artists in the exhibition, including the German Hans Bartels, the Frenchman Jules Dupré and the Dutchmen Jozef Israëls and Johan

Hendrik Weissenbruch. Those artists he did not refer to by name were dismissed in the following terms: 'I shall not speak of the rest, for that is dead art and one ought not to speak ill of the dead (*"de mortuis aut bene, aut nihil"*)'.[9]

The content of Diaghilev's next few texts remained fairly conservative. He wrote a long article about the Finnish artist Albert Edelfelt (ill. 11), who was a frequent collaborator in those years with Diaghilev's friend Bakst, followed by pieces on English and Scottish watercolourists and on the Dutch School, in which Diaghilev praised the then seventy-two-year-old Jozef Israëls, whom he had visited the previous year in The Hague (ill. 9). None of these documents furnishes any hint of unduly progressive sympathies on Diaghilev's part. He conformed largely to the prevailing standards of Realism, as propagated in St Petersburg at that time by the *Peredvizhniki* – the 'Wanderers'. Having sprung up as an anti-academic movement, the Wanderers had become fully assimilated in the artistic establishment by the 1890s. Their most celebrated members, such as Ilya Repin, had accepted positions at the Imperial Academy in St Petersburg and enjoyed the support of the court.

Diaghilev was more daring in his discussion in 1896 of Russia's submissions to a pair of foreign exhibitions (Berlin and Munich). He was withering in his criticism of the work destined for Berlin, which consisted largely of Wanderers: it was, he wrote, utterly lacking in coherence and, more importantly, primarily comprised artists who enjoyed very little popularity inside Russia itself. He was more positive about the entry for the Munich Secession, but still had his criticisms: while the quality of the canvases was not bad, this was hardly the kind of work that would help Russia to conquer Europe. 'If Russia has one thing to offer Europe, it is its youth and

ILL. 11 ALBERT EDELFELT, 'A CHILD'S FUNERAL', 1879. ATENEUM ART MUSEUM, HELSINKI

spontaneity.' Diaghilev was twenty-four at the time of writing. It was this insight that was to make him great and would ensure his success to the end of his life.

The first real fireworks came a year later, in 1897, when he reviewed the Wanderers' latest travelling exhibition in their own journal *Novosti* [The News]. Diaghilev and his group initially endorsed the Wanderers' programme, although their preoccupation with individual beauty and their focus on foreign art were bound eventually to set them at odds with the established painters and theoreticians within the group.

Diaghilev's polemical skills were highly refined. His style is casual and laconic, lending the fresh-faced critic an air of seniority. He did not indulge in any blunt rejection of the Wanderers but placed them instead in their historical and international context ('it is worth noting that the *Peredvizhniki*'s ideas may be understood in terms of the development of Russian art'). He began by exploring the Wanderers' history and the development of their ideas. By approaching them as a historian rather than a critic, he implicitly consigned their movement to the past. He confronted them forcefully with the fact that they had become more or less what they despised: a sclerotic establishment standing in the way of any artistic renewal. He also placed them effortlessly within an international tradition: '[The *Peredvizhniki*] found support for their ideas in German painting, which has always influenced our art.'[10]

Diaghilev's objectifying, non-ideological,

historicizing and above all international gaze pierced the intolerant, absolutist atmosphere that had so come to characterize the artists and theoreticians of the Wanderers. They believed themselves to be above criticism because of their advocacy of a closed, 'unilateral' system in which Russian art had its own path to follow: a path that could not be comprehended by Westerners, just as Western art was in fact incomprehensible – or at any rate superfluous – to Russian artists. This thinking, although rarely explicitly articulated, acted as a rampart behind which the artistically conservative but originally politically progressive Wanderers had planted themselves. By the 1890s, their progressive politics had given way to the nationalism to which the movement owed its new-found official status. What is more, by noting in passing that Russian art had always been influenced by Germany, Diaghilev shattered the nationalist myth the Wanderers had constructed so carefully.

Conflict with Stasov

No matter how refined Diaghilev's attack, it could not possibly go without a response. Not least because it emanated from a young and dynamic critic firmly ensconced within a group of rapidly rising young artists. And, to make matters worse, one writing in their very own journal, *Novosti*. The reply came from Vladimir Stasov (ill. 10), Russia's most powerful and respected critic of the day. Stasov began his career as a music critic, but in the course of the 1860s and 1870s became

ILL. 12 PAVEL SHCHERBOV ('OLD JUDGE'), 'AN INTIMATE CONVERSATION ABOUT AESTHETICS', 1898

the most important theoretician of the new 'progressive' and anti-academic movements in art and music. He was the leading figure behind the breakthrough of both the *Peredvizhniki* and the group of composers known as 'The Five', which included Mussorgsky, Rimsky-Korsakov and Borodin. Stasov was a less impressive figure than other major Russian thinkers like Belinsky and Stankevich. Uncritical and dogmatic, he was an insistent and unappealing polemicist: extremely intolerant, and of unshakeable integrity. He showed very little interest in developments outside Russia or – certainly after 1890 – in new economic and political developments in Russia itself. Be that as it may, there is probably no more influential figure in Russian culture of the second half of the nineteenth century. He was a tireless champion of the arts and was socially and politically active, too. Stasov was invariably present at every major event, exhibition or opera performance. He constantly visited artists and writers, putting them in touch with potential patrons. The success of painters like Repin, Surikov and Levitan and of composers like Mussorgsky and Rimsky-Korsakov is substantially attributable to Stasov's efforts. And he was as active in 1898 as he had been in 1868, when he guided the first steps of the new, independent artists' groups and stood at the cradle of a new art in Russia.

Diaghilev's articles were not the only factor eliciting Stasov's counterblast: the immediate prompt was the exhibition of Russian and Finnish artists at the Stieglitz Museum that Diaghilev had organized in January 1898. In that show, he brought together the entire young generation of Russian artists for the first time: Benois, Bakst, Somov, Lanceray, alongside more established though progressive artists like Vrubel, Serov and Levitan. The line-up was completed by the Finns Edelfelt, Gallen-Kallela and Blomstedt.

The patriarch of Russian art criticism girded himself up one more time to do battle with these new and malevolent developments in Russian art. What he saw in the exhibition was 'mostly horrifying: it is utterly worthless', and an 'orgy of degeneracy and insanity';[11] he was especially outraged by the work of Vrubel, Somov, Lanceray and Yakunchikova. In a subsequent article, Stasov went so far as to write of a 'court of lepers'.[12]

Diaghilev replied a few days later in an open letter to the editors of *Novosti* and more specifically to Stasov. He set the tone in the first few lines:

> Vladimir Vasilyevich. We are separated, you and I, by fifty years. I thus hesitate as I pick up my pen to respond to your long and elaborate lines, in which you cite my name about a dozen times. I feel somewhat strange, like a grandson answering the frightening voice of his old grandpa.... I ask you to take a look at yourself; at your face covered with grey hairs, at the whole of your venerable and powerful figure. You will make out in your features the fatal traces of fatigue and of profound and merciless old age. And somewhere, in the depths of your soul, a new awareness will

come unbidden that you have said all that you wanted and needed to say; that your arguments have been acknowledged and received; that you are no longer a warrior developing constantly in a pitiless conflict; that you are only repeating yourself; that you are, let us put it bluntly, finished; that you have been driven from the stage; and that your powerful voice no longer arouses the fiery emotions with which you played until recently.[13]

This is followed by a lengthy argument in which Diaghilev responds in detail to Stasov's assertions. But the editors of *Novosti* refused to publish Diaghilev's text, which prompted him to write a brief note to Stasov himself, enclosing a copy of his letter, asking whether the elderly critic would put in a good word for him with the journal's editors.

Dear Vladimir Vasilyevich,
I read your article in *Novosti* and have written a response which I wished to have placed in the same organ. Mr Notovich informs me, however, that he is not prepared to print my comments about you. I am thus turning to you in person to ask whether you would offer a few words in my defence, as to do otherwise would betray a desire to silence your opponents.
Yours with the greatest esteem,
Sergei Diaghilev[14]

We are struck once again by the cunning with which Diaghilev pursued his battle with Stasov, confronting him with the fact that his editors were refusing to accept criticism of their great leader and making him complicit with *Novosti*'s censorship, while at once obliging him to read the insulting open letter.
Henceforward, the entire evolution of *Mir Iskusstva* was to be dominated by the struggle against the artistic monopoly enjoyed by Stasov and the Wanderers. The polemics rapidly took on a public dimension, with the celebrated cartoonist Pavel Shcherbov reporting on the dispute between Stasov and Diaghilev in a series of caricatures. One of the first of these, entitled *An Intimate Conversation about Aesthetics*, shows a prostrate Diaghilev and a berserk Stasov being held in check by a more moderate critic called Kravchenko. The scene is set in a ring with *Novosti* readers looking on (ill. 12). It is worth noting that while the polemics

between *Mir Iskusstva* and the Wanderers might have been provoked to some extent by Diaghilev, the subsequent polarization was attributable first and foremost to Stasov and his supporters. More than that, in the early part of his career Diaghilev actually sought to build bridges between the old and new generations of artists, inviting the more progressive members of the Wanderers – figures like Repin and Levitan – to take part in his exhibitions and to publish in his magazine.

Break with Repin
Ilya Repin (ill. 13) was very much drawn to the new group of artists championed by Diaghilev in the mid-1890s. A celebrated member of the Wanderers, the painter had undergone several years of profound crisis, resulting in a breakdown in relations between himself and Stasov. It must have been a major coup for Diaghilev to have recruited Repin to his band. Repin took part from the beginning in the exhibitions Diaghilev organized and also supplied articles for *Mir Iskusstva*. However, shortly before the publication in mid-1899 of a special issue devoted to his art, he officially announced his intention to quit the group. Repin must have been particularly wounded by Diaghilev's article 'The Student Exhibition', in which he laid into the Academy, the formal idiom prevailing there and the lack of any serious art-historical knowledge he professed to detect among young students. Repin, who was substantially responsible for the policy pursued by the Academy, could hardly let such an attack pass. His withdrawal, which was applauded by Stasov, came as a severe blow to Diaghilev, as Repin and former students of his, including Vrubel and Serov, had been the principal source of *Mir Iskusstva*'s new-found respectability. It was entirely possible that other artists would now follow his example and turn their backs on Diaghilev. Fortunately for the latter and for Russian art in general that did not occur; however, it is easy to understand why Diaghilev blamed himself for the loss of Repin. Ironically, he refused to publish Repin's farewell letter – a direct attack on the aesthetics of *Mir Iskusstva*, which Repin subsequently had printed in the magazine *Niva* [Land]. The Repin controversy also featured in a number of Shcherbov cartoons (see ills. 14–15). Diaghilev naturally had to respond and the article he wrote, together with several others he published in the ensuing year, came to express his aesthetic programme. The ideas he put forward were not new

in either Europe or Russia; such is their passion, however, that they have become outright classic texts on the autonomy of the arts. The conflict with Stasov and Repin obliged Diaghilev to adopt a much clearer stance than had hitherto probably been his intention. In early issues of *Mir Iskusstva* and in his first exhibitions, Diaghilev and his fellows sought primarily to adopt the middle ground between progressive and conservative artists' groups. Their approach will also have reflected the fact that *Mir Iskusstva*'s two financiers – the railway magnate Savva Mamontov and Princess Tenisheva – also maintained close contacts with artists belonging to the Wanderers. Now, however, Diaghilev was obliged to declare his allegiances.

His response to Repin chiefly defended his attack on the Academy, stressing that he was not opposed to academic training as such, but to the institution's monopoly on the teaching of narrative, realist art. He repeatedly criticized Repin for the academicians' refusal to countenance any comparison with Western artists and for wallowing in self-imposed international isolation. Diaghilev reminded Repin of his condemnation of Monet ('a dilettante') and Gallen-Kallela ('semi-literate'). He also argued that Repin refused to acknowledge comparisons with foreign artistic movements as that would oblige him to relinquish a specifically 'Russian' stance that was more moral than aesthetic. Once again, the text was far more polemical than sober or principled. Above all, Diaghilev was keen to point out the inconsistencies in Repin's article and was unable to resist making tart references to Repin's age and provincialism as opposed to the youth and international pretensions of the *Mir Iskusstva* group. Publication of Diaghilev's article ruled out the final possibility of any reconciliation between *Mir Iskusstva* and the Wanderers.

ILL. 13 ILYA REPIN, SELF-PORTRAIT, 1887. STATE TRETIAKOV GALLERY, MOSCOW

Beauty above All

A year later, Diaghilev published the article 'Art Critics' in *Mir Iskusstva* – probably the most carefully conceived of his early writings. It is clear once again that he primarily defined his aesthetic programme – the goal of art is absolute beauty – through his rejection of the notion of artistic progress or national identity. Art is timeless and international or it is nothing. 'That we consider Rembrandt to be a good artist does not make Fra Beato [Angelico] any better or worse. All movements have the same right to exist, as the value of a work of art does not depend on the movement from which it sprang.' In this way, the aestheticism and individualism of *Mir Iskusstva* did not arise from a positive appreciation of art for art's sake (an expression, incidentally, which Diaghilev never used) but from a rejection of the uniform, intolerant system of non-artistic values that had hitherto dominated Russian art. It also explains why attempts to characterize *Mir Iskusstva* as a strand within wider international movements rarely succeeded. The group was presented, for instance, as the Petersburg platform for international Symbolism[15] and, more specifically, as the Russian variant of the 'Nabis' group in France.[16] Such characterizations fail to do justice, however, to the multiplicity of artistic attitudes propagated by *Mir Iskusstva* or to their lack of consistency. Realism and Symbolism, French and German art, and internationalist and nationalist attitudes constantly and cheerfully co-existed in the magazine. The chief desire of *Mir Iskusstva*, with Diaghilev as its spokesman, seems to have been to reject a monolithic notion of art and to promote a pluralistic alternative.

One of the most important characteristics of the new movement in Russian art was, he claimed, 'the absence of precise theoretical arguments underpinning the activity of modern artists'.[17]

ILL. 14 PAVEL SHCHERBOV ('OLD JUDGE'), 'IDYLL', 1899. STATE RUSSIAN MUSEUM, ST PETERSBURG

His most persuasive defence of the autonomy of art – the independence of the work of art from the art market, theoretical systems and the fashion of the day – comes during his description in the same article of an exhibition of works for sale:

> Essentially, large exhibitions are not a celebration of art but a pestilence. There is nothing more corrupting for a work of art than to be exhibited to a crowd in an ill-proportioned room, one frame cheek by jowl with another, the canvases they contain having been painted by different artists, with entirely different backgrounds and artistic temperaments. There is something repellently vulgar about that endless row of golden frames, exhibited and offered for sale. There is nothing intimate or artistic in those palaces of glass, with their fatal resemblance to covered market-halls, which have exactly the same kind of glass cupolas and the same never-ending streams of humanity.[18]

It must come as a surprise to those who like to portray Diaghilev as a showman or populizer to hear him denouncing large-scale public events in this way. And yet the ideas expressed here were to remain at the heart of his work until the end of his life. Diaghilev always managed to steer a middle course in Paris between Cubists and Surrealists, tradition and renewal, Stravinsky and Strauss, Petipa and Nijinsky, because of his fervent belief in the individual and autonomous status of every work of art. It was precisely in a Paris riven by artistic tribal wars that Diaghilev was at liberty to champion one movement one day and another the next. And it also explains why, despite being the head of a large business, he felt able to shock and provoke the public, as his ultimate motivation was always his own, hyper-individual taste and unshakeable faith in the inviolability of beauty. That faith lies at the core of Diaghilev's artistic identity.

In an interview for the *New York Times* in 1916, Diaghilev referred several times to his role as an art critic in St Petersburg. 'We were all

ILL. 15 PAVEL SHCHERBOV ('OLD JUDGE'), 'IMMENSE JOY', 1900. STATE RUSSIAN MUSEUM, ST PETERSBURG

revolutionaries when we fought for the cause of
Russian art, and it is pure chance that I did not
become a real revolutionary but one of colour and
music.... I spent those years studying Russian
art of the sixteenth, seventeenth and eighteenth
centuries ... it was precisely there that we found
our inspiration.'[19]

The proposition that the years in which Diaghilev
was solely engaged with art were merely a
transitional period or that his decision to focus
entirely on art was purely opportunistic cannot,
therefore, be sustained. On the contrary, it was
through the battles he waged in St Petersburg on
behalf of a freer and more fertile artistic climate
that he developed the ideas and methods with
which he was later to conquer the world through
an entirely different branch of the arts.

ORIENTALISM AND EXOTICISM: THEIR INTERPRETATION BY DIAGHILEV AND HIS RUSSIAN DESIGNERS

Alexander Schouvaloff

I define the terms 'orientalism' to mean Asiatic, that is to say anything Egyptian and East of Suez, and 'exoticism' to mean ancient Russian or even just Slav. This applies to the work of those Russian artists who worked with Diaghilev and the *Mir Iskusstva* – 'World of Art' – group and subsequently with him and the Ballets Russes. Everything about the Ballets Russes, which only ever performed in Western Europe and America,[1] was considered to be 'exotic', because nothing like their ballets had ever been seen before. They were new to the West – strange, exciting, and often violent and erotic.

Russia has always stood on a delicate bridge between the East and the West. Most of the time it does not know which way it is facing. This is because Russians, at least educated Russians, are confused about their identity. The Russian philosopher Nikolai Berdyaev wrote that 'the inconsistency and complexity of the Russian soul may be due to the fact that in Russia two streams of world history – East and West – jostle and influence one another. The Russian people are not purely European and it is not purely Asiatic. Russia is a complete section of the world – a colossal East–West. It unites two worlds, and within the Russian soul two principles are always engaged in strife – the Eastern and the Western.'[2] This schizophrenic stance has been in existence since before the seventeenth century, when Peter the Great deliberately faced west. However, some

Russians favour looking to the East, others to the West. Although this duality had been apparent for many years it became more formalized in the nineteenth century when the opponents were divided into two camps: the 'westernizers' and the 'slavophiles'. The two attitudes were mostly taken up by the writers of the period but their differing influences managed to permeate all cultural activity, including painting.

The 'slavophile' attitude was nurtured by the railway magnate Savva Ivanovich Mamontov. In 1870 he bought the estate Abramtsevo which he developed into a colony for Russian artists where he hoped to realize his aim: the restoration of a genuinely Russian, 'slavophile' art based on traditional peasant folk art and folk tales. Aiming at a synthesis of all the arts, he started a private opera company on his estate producing 'exotic' Russian operas by Russian composers such as Rimsky-Korsakov's *Sadko*, *The Snow Maiden*, and *The Maid of Pskov*, Mussorgsky's *Khovanshchina* and *Boris Godunov* (with Chaliapin). Mamontov used painters in sympathy with a traditional Russian style to decorate the productions, including the superb portraitist Valentin Serov and his friend, the melancholy Symbolist, Mikhail Vrubel, Viktor Vasnetsov, Konstantin Korovin and others equally concerned with the progress of art in Russia. This was the group of artists with whom Diaghilev would later have close professional connections.

St Petersburg looked west whereas Moscow looked east, which created a conflict. Wladimir Weidlé described the difference between the two by stating that

the 'westernizers' saw the salvation of their country in a complete and rapid assimilation of western culture; the 'slavophiles', on the other hand, believed Russia could only be truly herself by strengthening all that separated her from the West, by remaining loyal to the distinctive characteristics of her past and developing a culture that should be in direct opposition to the culture of the West.[3]

This explanation, however, ignores the crucial fact that for most Russians, whichever way they face, to be Russian is to be Russian Orthodox, which is an eastern faith, and artists have always been influenced by its ritual, its traditions and its imagery.[4]

In the late 1880s a group of student friends in St Petersburg started to hold regular meetings at the home of Alexandre Benois (ill. 8) and formed themselves into a society called the 'Nevsky Pickwickians'. Apart from Benois this group consisted of Benois' nephew Eugene Lanceray, Konstantin Somov, Walter Nouvel and Dmitri Filosofov (Philosophoff).[5] They discussed artistic ideals, philosophical notions and aesthetic principles. While they conducted serious and structured meetings with a programme of learned papers given by members,[6] they had, in the beginning, no definite aims or objectives except to explore the world of art. But everything changed in 1890 when the group was joined by Léon Bakst (ill. 16), Nikolai Roerich (ill. 27) and Sergei Diaghilev who, arriving from Perm in the distant

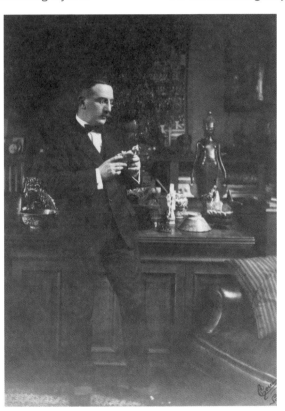

ILL. 16 LÉON BAKST, 1923. PRIVATE COLLECTION

Urals, introduced by his cousin Filosofov, was always teased by the rest of the group for being a provincial. Benois, the intellectual of the group, wrote later that an

important bond was our Europeanism or Westernism. By nature we all belonged to Europe rather than to Russia. The majority of us ... had no Russian blood in us. And if it is true that Somov and Filosofov belonged to the old Russian gentry, their upbringing and personal inclinations were impregnated through and through with western culture. The most Russian of us all was perhaps Diaghilev, and it was just this 'Russian side' of Diaghilev that aroused our antagonism – all the more because his characteristically Russian qualities were, from a universal point of view, the least acceptable ... Diaghilev set to work to catch us up by becoming more and more of a 'Westerner', until there came a moment when the position seemed to be reversed; it was we who had to defend everything Russian, now thoroughly despised by him.[7]

Benois' assessment of Diaghilev's stance is not entirely accurate. Diaghilev's eyes were certainly opened to Western art by his trips abroad in the early 1890s, but he still maintained a loyalty to the essential 'Russianness' of Russian art. Having faced one way, Diaghilev then turned to face the other way. Benois' statement about Diaghilev's opinion of Russian art is contradicted by Diaghilev's letter to the painters Bakst, Benois, Botkin, Vasnetsov, Golovin, Korovin, Lanceray, Levitan, Maliutin, Nesterov, Pereplechikov, Polenova, Serov, Somov, Yakunchikova and others dated 20 May 1897 in which he sought

the support of Russian artists in the preparation of an exhibition he was planning:

At this particular moment Russian art finds itself in that transitional position in which history puts every embryonic trend, when the principles of the old generation collide and struggle with the newly developing demands of the young.... Talented youth everywhere has united together and found a new cause on new principles with new programmes and aims.... Our art not only has not fallen, but perhaps, on the contrary, there is a group of young artists scattered round different towns and exhibitions, who, gathered together, could prove that Russian art exists, that it is fresh, original and could introduce a lot of novelty into the history of art ... I believe that the best moment has now come to unite and like a cohesive whole occupy a place in the life of European art.[8]

Diaghilev succeeded in his appeal and the result was an impressive exhibition of Russian art by Russian painters from both St Petersburg and Moscow in Baron Stieglitz's Museum[9] between 15 January and 15 February 1898.
Meanwhile, at the same time as writing to the artists, he wrote to Benois on 24 May 1897: 'I want to nurse Russian painting, clean it up, and, above all present it to the West, extol it in the West.'[10] Benois later said that this was when Diaghilev realized that his real ambition was eventually to take Russian art to the West. But first he decided to start a magazine. In another letter to Benois, dated 8/20 October 1897, Diaghilev wrote: 'You already know ...

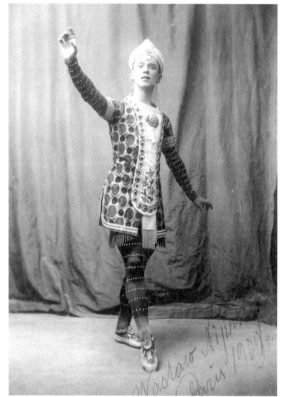

ILL. 17 VASLAV NIJINSKY AS THE HINDU PRINCE IN 'LE FESTIN', 1909.
COLLECTION OF THE AUTHOR

that I am totally immersed in various projects, one more grandiose than the next. At present I'm planning this magazine in which I hope to combine the whole of our artistic life, that is to say to put true painting in the illustrations, to say sincerely what I think in the articles, and furthermore to arrange, in the name of the magazine, a series of annual exhibitions.... I still don't know the title of the magazine.'[11]

Several titles were thought of. Benois suggested 'Renaissance'; among other suggestions were 'Forwards', 'The New Art', and 'Beauty'. Eventually they agreed on the title *Mir Iskusstva* or 'The World of Art'. This all-embracing title shows that Diaghilev and his editorial board were committed to confining themselves not merely to Russian art but to the world of art at large. Diaghilev persuaded Princess Tenisheva[12] and Savva Mamontov to sponsor the magazine and be the publishers. *Mir Iskusstva*, lavishly produced with graphic designs by Somov, Bakst and others, was published from November 1898 to December 1904. During its short but influential period of publication it covered an eclectic range of topics concerned with Russian art and artists such as Vasnetsov, Levitsky,[13] Pushkin, Korovin, Vrubel, the Russian arts and crafts movement emerging from the Mamontov and Tenishev estates, and European artists such as Beardsley, Puvis de Chavannes, Whistler.[14]

Mir Iskusstva folded through lack of financial support. Diaghilev now set his sights on his stated ambitious goal: to show Russian art to the West.[15] He chose Paris as his shop window because at the time it was the cultural centre of Europe and therefore of the West. The first 'Saison russe' was

an exhibition of paintings in 1906,[16] followed by a series of concerts of Russian music in 1907,[17] and the first productions of Russian operas and ballets in 1908[18] and 1909. Finally, in 1910, Diaghilev produced his first complete programme of ballets, and the World of Art became the Ballets Russes. They continued for twenty years until Diaghilev's early death in 1929.

Before 1907 Diaghilev had no special enthusiasm for ballet. It was only after he had been taken by Benois to a performance of *Le Pavillon d'Armide*, which Benois had designed, that Diaghilev said to him: 'This must be shown to Europe.'[19] His sympathies were instinctively directed more towards opera, where Wagner had achieved a complete synthesis between music and drama, but he recognized from Benois' example that there was greater potential for achieving this in ballet. In preparing the programme for his first season of ballets in Paris in 1909, Diaghilev relied for the most part on a repertory of works, choreographed by Fokine, which had already been performed in St Petersburg. But his plans also included a new ballet, specifically on a 'Russian' theme. This work, to be based on the Russian fairy story of the Firebird, did not materialize. Instead Diaghilev arranged a suite of dances from operas and ballets already familiar to the dancers presented under the general title of *Le Festin*. But he wanted to retain an element of the Firebird in his programme, so one of the dances was called *L'Oiseau de feu*,[20] danced by Tamara Karsavina as the Firebird and Vaslav Nijinsky as the Golden Bird, transformed into a Hindu prince (ill. 17). Their costumes in exotic and oriental style, the first costumes to be seen in the West designed by Léon Bakst, created a sensation.

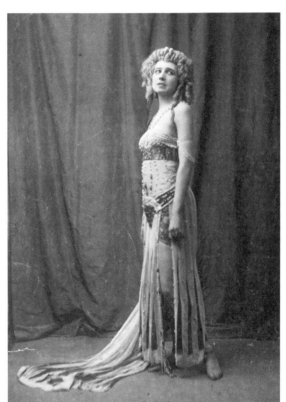

ILL. 18 IDA RUBINSTEIN IN 'CLÉOPÂTRE', 1909.
COLLECTION OF THE AUTHOR

Of all the artists who worked with Diaghilev's Ballets Russes Bakst was the most adept at facing both east and west at once. This was because Bakst felt himself to be an outsider as he was Jewish. Benois remarked that 'one could sense that he was an alien, that there was something exotic about him, something which "belonged to the Orient"'.[21] It was a perceptive observation because although Bakst travelled frequently in the West and effectively lived in Paris, with interruptions, between 1893 and 1899, he nurtured his interest in oriental art and architecture by frequent visits to the Louvre. He was certainly also influenced by the general interest in the Orient being shown at the time by many artists and writers, both Russian and French. He would also have seen the illustrated articles on oriental subjects which appeared regularly in magazines, especially the French weekly *L'Illustration*. There is no doubt that Bakst was attracted to all manifestations of oriental art, as can be seen from the photographs of him taken in his Paris apartment where he is surrounded by his own oriental Asian objects. But a more impressive effect on Bakst had the performances on 28 and 29 October 1900 of the ballet troupe of the Royal Siamese court at the Imperial Mikhailovsky and Alexandrinsky theatres in St Petersburg which he and Michel Fokine both saw. The spectacle of the dancers and the dancing made such a strong and influential mark on the two men that they began to see the art of ballet differently. Bakst recorded his impressions in his painting *Siamese sacred dance* (1901; cat. 1) – impressions of costumes, head-dresses, gestures and setting which then recurred later in some of his theatre designs.

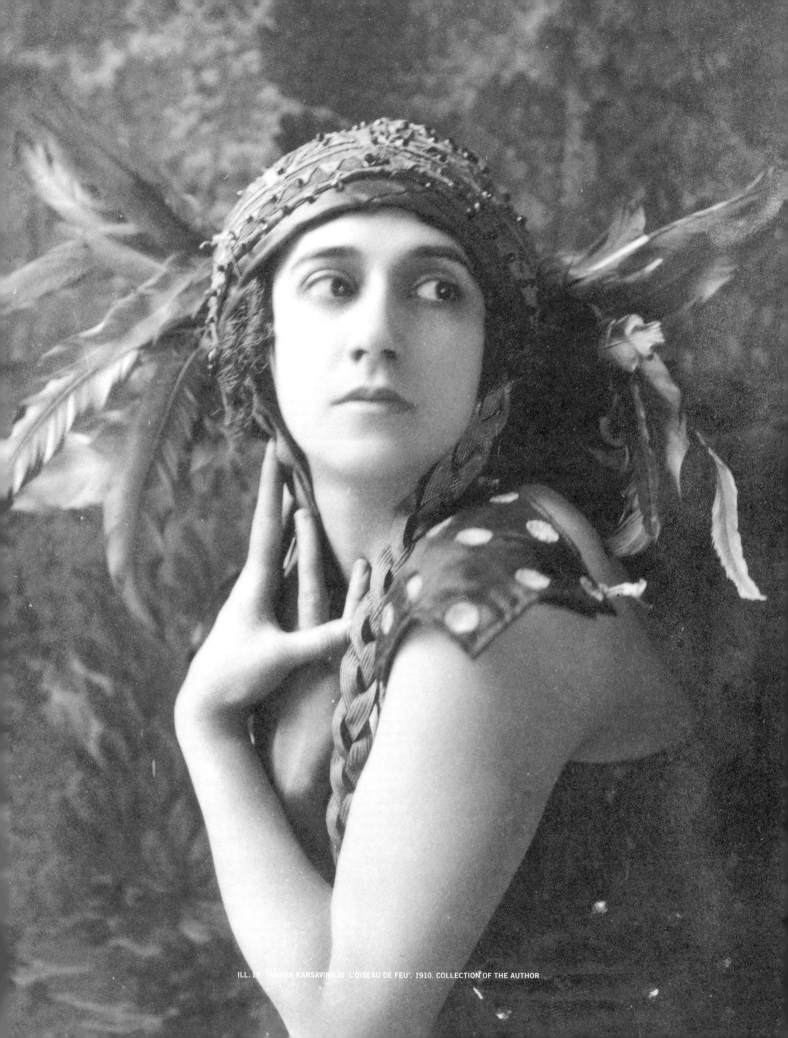

ILL. 19 TAMARA KARSAVINA IN 'L'OISEAU DE FEU', 1910. COLLECTION OF THE AUTHOR

The feeling of being an outsider would have struck Bakst again when he met Liubov Gritzenko, widow of the painter Nikolai Gritzenko and one of Pavel Tretiakov's daughters, in 1902 (cat. 2). In order to marry her he was obliged to convert to Christianity.[22] This obligation became so painful for him that it caused periods of deep depression. Eventually he divorced his wife, left his son and stepdaughter, returned to Judaism, and moved in about 1912 to live permanently in Paris. He therefore continued, in many ways, to remain an outsider. Of all the Russian designers during the first period of the Ballets Russes Bakst was also the busiest. Between the first season in 1909 and the last before the First World War in 1914 he designed more productions for Diaghilev than anyone else. In addition, during the same time and to Diaghilev's great annoyance, he also designed four huge productions for Ida Rubinstein[23] (ill. 18) as well as sets and costumes for Anna Pavlova and several other managements. Judging from the tone of their correspondence, I don't think Diaghilev liked Bakst very much. He thought him to be too vain and pernickety, but he put up with his temperamental capriciousness, recognizing and valuing Bakst's special talent, and relied on him to design and deliver a whole range of different ballets. With apparently total ease Bakst was able to switch from one style to another. He was a methodic scholar and carefully studied the appropriate artefacts, architecture and landscape for every production before he designed it. He used the sketches he made of objects he had seen in museums in St Petersburg and Paris or of landscapes he had visited in the Caucasus, Greece and Crete, the south of France and Tuscany as *aides-mémoire*. (For example, as part of his

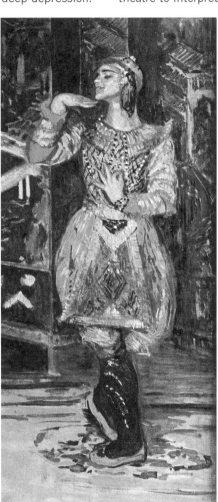

ILL. 20 VASLAV NIJINSKY IN 'LES ORIENTALES', 1910.
BIBLIOTHÈQUE NATIONALE DE FRANCE, PARIS

setting for the garden scene of *Boris Godunov* [1913], he made an accurate reproduction of the huge stone sculpture *Appennino* by Giambologna he had seen in the grounds of Pratolino, the Demidoff Villa outside Florence.) Bakst used his innate artistic licence and understanding of the theatre to interpret a given period or a style to suit each production. In 1907, with his friend Valentin Serov, he visited Greece and Crete, where he saw the excavations at Knossos. This journey had a profound impact on him and effectively established his palette. He would settle on a particular gamut of colours for each production so that the costumes would fit into the colour scheme of the décor to become an intrinsic and inseparable part of the total stage picture. He now evolved his own 'oriental' and 'exotic' style which came to be known as 'Bakstian'. Occasionally his costumes overpowered the dancer. The only style that eluded him was the contemporary style, which is why his costumes for *Jeux* (1913) were changed by Diaghilev at the last minute. All but two of the ballets designed by Bakst for Diaghilev before 1914 were choreographed by Michel Fokine. (The exceptions were *L'Après-midi d'un faune* [1912] and *Jeux*, both choreographed by Nijinsky.) Fokine and Bakst worked closely together in developing each ballet and shared a common appreciation of, and an intellectual devotion to the past. As Lincoln Kirstein has written: 'Fokine, in the body of thirty years of constant work has never invented a single ballet with a contemporary subject ... Fokine was brought up in a period (from 1900 to 1914) when the "past" was more actual, more keenly felt than everyday events in Petersburg, London, or Paris. His past was Persia, India, Egypt, "Old" Russia, Georgia, the Venice of Veronese, Viennese

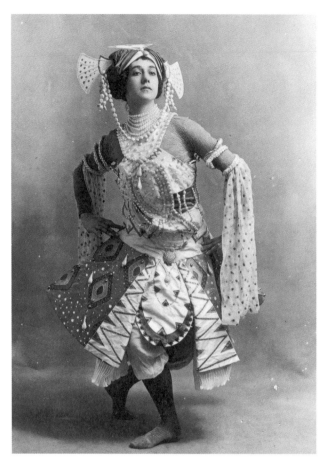

ILL. 21 TAMARA KARSAVINA IN 'LE DIEU BLEU', 1912.
COLLECTION OF THE AUTHOR

Biedermeirer or Le Nôtre's Versailles. In this he was enormously aided by collaboration with Léon Bakst.'[24] His past, too, was Fokine's and was more real than the present. All theatre is collaborative and the partnership between these two was uniquely successful. Their success also depended on the composers and the dancers and Diaghilev was lucky to have the extraordinary Nijinsky and Karsavina. The early ballets, the Egyptian *Cléopâtre* (1909) and the Persian *Schéhérazade* (1910), with Fokine's passionate choreography and Bakst's sensual colours, were particularly shocking to the staid Parisian audiences. If these ballets had not been Russian and therefore excusable as being both 'oriental' and 'exotic', their eroticism would have been condemned as pornographic. Bakst recognized that theatre design is a matter of using artificial means to achieve something believable. The *Cléopâtre* designs reflected the heat and passion of Egypt. Huntly Carter wrote that

Cléopâtre illustrated his [Bakst's] mastery of chromatic combinations, and the use of the five primary colours in endless harmonies, as well as his right understanding of the note of style to be found in coherence and uniformity. The whole was held together by a tremendous design or framework into which he poured characteristic Egyptian motives which were caught up and repeated in the movements, costumes, and even in the ornaments worn by the dancers. This dominant mood flowed uninterruptedly from beginning to end and thus his contribution to the Ballet was seen to be the essential line and colour of one great rhythmic movement.[25]

Change the title of the ballet to any of the ballets Bakst designed and change the definition of the characteristic motifs from Egyptian, to any other 'oriental' characteristic, such as Persian for *Schéhérazade* and *La Péri* (1911 but not

produced), or Georgian for *Thamar* (1912), Siamese for *Les Orientales* (1911; ill. 20) and *Le Dieu bleu* (1912; ills. 21–23), fantasy Greek for *Narcisse* (1912), Greek for *L'Après-midi d'un faune* (1912; ill. 24) and *Daphnis et Chloé* (1912), or any other he used, and you have the perfect description of Bakst's technique.

Bakst's settings were often complicated incorporating a number of different elements. The motifs used in the setting for *Schéhérazade*, which created such a stir when it was unveiled in Paris in 1910, were drawn from several sources. The three female figures to the right of the staircase recall the marble throne constructed for Fath 'Ali Shah of Isfahan and the earlier throne in the Golestan palace in Tehran (perhaps taken from a photograph in *L'Illustration* for 21 January 1893 when Bakst was in Paris), the cubicle building with three lofty pointed arches towards the centre of the set is of the Safavid caravansaray type of the sixteenth–seventeenth century, the three tall near 'Classical-Greek' columns with a horizontal rectangular element behind were suggested by a view or views of Persepolis which Bakst would have seen illustrated in books. The ballets that followed *Schéhérazade* did get less barbaric but no less 'exotic'. The extraordinary, unrealistic set for *Thamar* came both from Bakst's visit to the Caucasus and from a well-known collection of photographs of the region found in St Petersburg. For his setting for *Le Dieu bleu* Bakst may well have been inspired by the photographs of the ruins of the huge heads carved in stone set in the overgrown temples of Angkor-Thom and Angkor-Vat in Indo-China (Cambodia) pictured in articles by Eugène Brieux in May–June 1910 and by Pierre Loti in December 1911 in *L'Illustration*.[26]

Diaghilev's 'Russian' ballet *L'Oiseau de feu*, based on the traditional Russian fairy story, was finally achieved for the 1910 season (ill. 19). Liadov was the commissioned composer. He bought some music paper but never composed a note. Stravinsky replaced him and became world-famous overnight. Alexander Golovin designed the sets and costumes in the Russian folk style. Diaghilev was not altogether satisfied with the result. Ruthless, he asked Bakst to re-design the costumes of the Firebird, Ivan Tsarevich and the Beautiful Tsarevna (cat. 94). They, too, were in the Russian style, but exaggerated as only Bakst could devise.

Having discovered Stravinsky and promoted him with such dazzling success, Diaghilev followed *L'Oiseau de feu* with his *Petrouchka* (ill. 25) in 1911. Although the story is set in Russia during the Butter Week Fair in St Petersburg in 1830, Stravinsky did not consider his puppet Petrushka to be specifically Russian but the 'immortal and unhappy hero of every fair in all countries'.[27] Diaghilev asked Benois to design the production. Benois had seriously quarrelled with Diaghilev over the credits for *Schéhérazade* and had resigned from his position as artistic director of the company. They were always quarrelling, with Benois, being very touchy, regularly resigning in a huff and Diaghilev then making it up. In this case Diaghilev managed to entice Benois back to the fold knowing that he would not be able to resist the offer to create the designs for *Petrushka*. Indeed, Benois later wrote:

> Petrouchka,[28] the Russian Guignol or Punch, no less than Harlequin, had been my friend since my earliest childhood. Whenever I heard the loud, nasal cries of the travelling Punch and Judy showman: 'Here's Petrouchka! Come, good people, and see the Show!' I would get into a kind of frenzy to see the enchanting performance.... As to Petrouchka in person, I immediately had the feeling that 'it was duty I owed to my old friend' to immortalize him on the real stage. I was still more tempted by the idea of depicting the Butter Week Fair on the stage, the dear *balagani* [fair booths] which were the great delight of my childhood.[29]

Benois' designs were certainly Russian. The curtain rose to reveal an authentic early nineteenth-century Russian fair. The crowd scenes, carefully choreographed by Fokine, were filled with authentic Russian characters following their trades or enjoying themselves in realistic detail. It was considered to be 'exotic' by Parisian audiences because it was so foreign to them, but it was not quaint or folksy. Unlike Bakst, Benois was incapable of fantasy. His intellectual seriousness and his art-historical knowledge always held his imagination in check.

Stravinsky's next ballet was *Le Sacre du printemps*[30] or *The Rite of Spring* (ill. 26), which he elaborated with Nicholas Roerich. (In fact he interrupted his work on it to finish *Petrouchka* first.) They described it as a 'Tableau of pagan Russia'. Stravinsky had dreamed of a pagan ritual in which a chosen sacrificial virgin dances herself

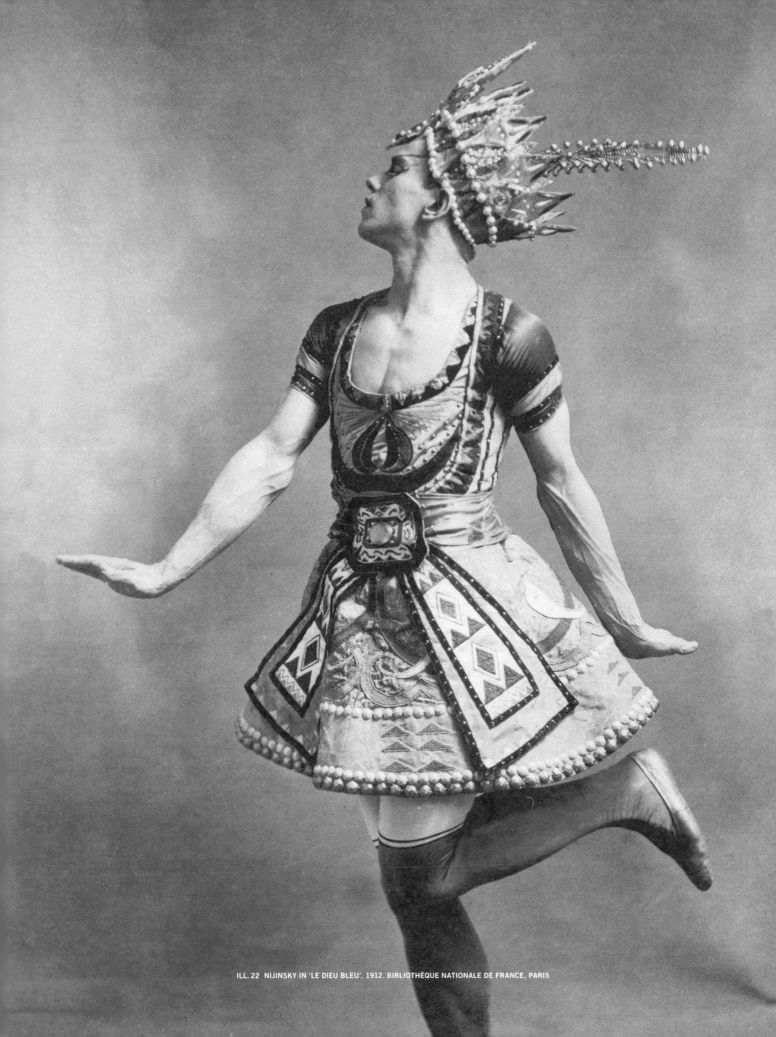

ILL. 22 NIJINSKY IN 'LE DIEU BLEU', 1912. BIBLIOTHÈQUE NATIONALE DE FRANCE, PARIS

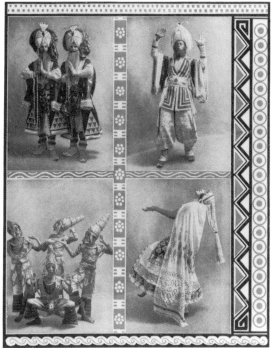

ILL. 23 GROUP OF DANCERS IN 'LE DIEU BLEU', 1912. COLLECTION OF THE AUTHOR

to death. Diaghilev suggested to Roerich (ill. 27) that he should work with Stravinsky. Roerich had already successfully designed the *Polovtsian Dances* from Borodin's opera *Prince Igor* in 1909 evoking the vast and wild steppes of ancient Russia. He was therefore ideally suited to invent the plot of *Le Sacre du printemps* and visualize it on stage as he had a serious archaeologist's interest in so-called 'Old Russia', which he combined with his artistic ability to give an authentic scenic interpretation to Russian music. Roerich used to spend time on Princess Tenisheva's estate Talashkino studying her collections of Russian ethnic art. Stravinsky joined him there:

> I set to work with Roerich, and in a few days the plan of action and the titles of the dances were composed. Roerich also sketched his famous Polovtsian-type backdrops while we were there, and designed costumes after real costumes in the Princess's collection.[31]

Roerich's set designs were of wild, green Russian landscapes with symbolic 'sacred stones' and poles hung with votive skins and antlered heads under threatening cloud-filled skies. W. A. Propert described the effect:

Roerich's scenery was pale in colour, his dresses of primary green and red in complete accord with the chilly atmosphere and crude violence of the action – it was learned, impressive and personal, another example of the archaeological spirit that informs without intruding.[32]

It was not Stravinsky's music alone that shocked the Parisian audience but its combination with Nijinsky's revolutionary choreography and Roerich's primitive sets and costumes (ill. 28).

After yet another quarrel, Diaghilev, anxious to patch things up again between them, asked Benois to design both Stravinsky's next work, the opera *Le Rossignol*, and Rimsky-Korsakov's opera *Le Coq d'or* for the 1914 season. Benois was beguiled but then later, as he became too busy designing and directing Goldoni's *La Locandiera* for the Moscow Art Theatre, decided that he had to give up *Le Coq d'or*. Once again, Benois' intellectual side coming to the fore, he applied all his research and knowledge of Chinese art combined with his innate good taste into creating genuine oriental sets and costumes. Benois described his approach to the design problem:

33

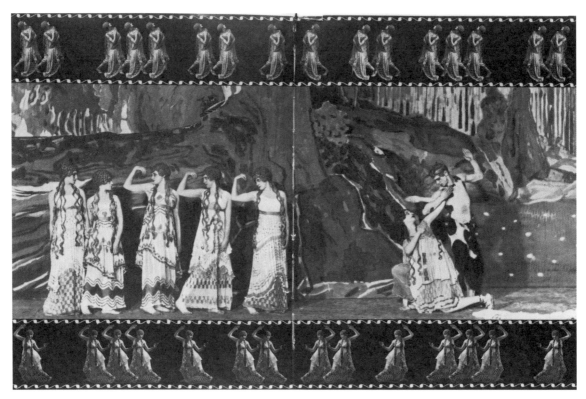

ILL. 24 SCENE FROM 'L'APRÈS-MIDI D'UN FAUNE', 1912. IN: 'COMOEDIA ILLUSTRÉ', 7

ILL. 25 NIJINSKY IN 'PETROUCHKA', 1911.
BIBLIOTHÈQUE NATIONALE DE FRANCE, PARIS

ILL. 26 ONE OF THE ELDERS IN 'LE SACRE DU PRINTEMPS', 1913.
COLLECTION OF THE AUTHOR

34

The sea and landscape of the first act, the throne-room and the golden bedroom in the Emperor's palace, gave me an opportunity to express all my infatuation with Chinese art. At first I hoped to keep to the style of the somewhat ridiculous Chinoiseries fashionable in the eighteenth century, but as the work advanced I became irritated by their insipidity. My love of genuine Chinese art began more and more to permeate my production. My collection of popular Chinese colour-prints, which had been brought for me from Manchuria, served as valuable material for the costumes. The final result was a Chinoiserie *de ma façon*, far from accurate by pedantic standards and even, in a sense hybrid, but undoubtedly appropriate to Stravinsky's music.[33]

Benois' personal assessment flatters himself but is not accurate. Though the sets and costumes appear to be impressively realistic they lack a lightness of touch and seem oppressive. The contrast between them and the later 'oriental' set and costumes designed by Henri Matisse for *Le Chant du rossignol* (the ballet from the opera) in 1920 reveals the difference between serious artistic accuracy and brilliantly imaginative interpretation. For the design of *Le Coq d'or* Benois suggested Natalia Gontcharova, or so he later claimed. It is more likely that Diaghilev, knowing her already and impressed by her gigantic exhibition of 768 works in Moscow in August 1913, approached her himself. Mary Chamot supports such a view: 'In choosing Goncharova ... Diaghilev showed his usual artistic flair and foresight. He was always one step ahead of fashion by encouraging the latest movement in art, even anticipating the next craze.'[34] Although Gontcharova alone was credited with designing the sets and costumes (cat.143–47), she undoubtedly worked on the production with her lifelong companion, Mikhail Larionov, whom she had known since before 1900. They were both fascinated by Russian folk art and much influenced by icon painting and the primitive *lubki* (plural of *lubok*). These were popular, hand-coloured prints on cheap paper or board made from woodcuts, and later engravings, illustrating moral or religious stories, historical events or folk tales. They were produced in Russia from the seventeenth century for the edification of the illiterate peasants. Larionov had a remarkable collection of *lubki*. In 1913,

using his collection and borrowing from other collectors, he organized an exhibition of about 200 pieces with the title *Original Icons and Lubki*. The popular prints exhibited were not only Russian but included examples of Japanese, Chinese, French, Jewish and Tartar prints from the eighteenth and nineteenth centuries. Russian *lubki* were the inspiration for the designs for *Le Coq d'or*. The idea obviously appealed to Diaghilev. He telegraphed Benois in Moscow:

Please warn Gontcharova. Tuesday 3 o'clock I and Fokine will be with her to talk about *Zolotoi petushok* [*Le Coq d'or*]. Essential for Fokine to see her *lubki*. Will arrange meeting with you after 4 o'clock. Fokine returns to Petersburg that evening. Please be free.[35]

In his memoirs published much later Fokine, who made the choreography, wrote: 'In the dances, poses, groups, gestures I tried to convey the style of the Russian *lubok* and the fantastic Orient which are so quaintly interlaced in the music of Rimsky-Korsakov.'[36]

In 1915 Gontcharova and Larionov joined Diaghilev in Switzerland (ill.29), after which they never lost touch with him and worked together and separately on several productions. Gontcharova's designs for *Liturgie* (cat.151–60), based on the passion of Christ, rehearsed but not performed, were inspired by icon painting. Russian folk art with its crude decorative patterns in bright, garish colours inspired Larionov's bold Russian neo-primitive designs for Rimsky-Korsakov's *Soleil de nuit* (1915; cat.172–74), Liadov's *Contes russes* (1917; cat.178, 181–82), both with choreography by Léonide Massine (ill.30), and Prokofiev's *Chout* (*Le Bouffon*) (1921; cat.175–77, 183–84, 220–22), choreographed by Larionov and Slavinsky. Larionov's designs were always praised by the critics but almost always abhorred by the dancers who found the costumes they had to wear exceedingly uncomfortable and well-nigh impossible to dance in. Larionov paid no attention. Gontcharova's ideas for the designs for Stravinsky's *Noces* (1923), choreographed by Bronislava Nijinska, went through at least four distinct phases and took almost as long to develop as the composition of the score. She started on the project soon after she joined Diaghilev in 1915. At first, as she wrote,

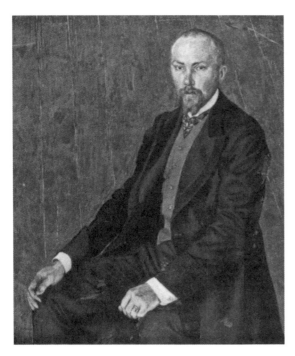

ILL. 27 NIKOLAI ROERICH. BIBLIOTHÈQUE NATIONALE DE FRANCE, PARIS

ILL. 28 IGOR STRAVINSKY, MRS KOVCHINSKY, DIAGHILEV AND LÉON BAKST. PHOTOGRAPH BY H. PERRET. COLLECTION OF THE AUTHOR

It was the festive, folk aspect of weddings that stood out for me, the colourful costumes and dances that connect weddings with holidays, enjoyment, abundance and happy vitality. Therefore the costumes I designed were derived from peasant forms and vivid colours, harmonized sometimes in unison, sometimes by opposites, almost without intermediates, and this applied to decorations and curtains as well.[37]

But the bright and garish colours and the bold patterns worried her; soon they no longer seemed right. She made new sketches using geometric patterns and completely changed the atmosphere and feeling; but these, too, seemed inappropriate. She then remembered country weddings in early spring in northern Russia. Her third set of costume designs used spring flower motifs in pastel colours, but these, too, she thought unsatisfactory. With the

imminent production of the ballet she discarded all her previous ideas. Nijinska claimed to have influenced Gontcharova into simplifying the design but Gontcharova denied this. In making the final design she confined herself to using the muted colours of the sky and the earth for the sets, with blue signifying hope, grey the past, and yellow ochre anxiety, and brown and white for the costumes, all the colours symbolizing different states in a marriage. Perhaps the final sombre designs also symbolized her grief at the loss of her homeland, although she returned in spirit to her remembered Russia when she created the joyous backcloth of a myriad brightly coloured Russian churches for the revival of *The Firebird* in 1926. After the First World War, after his disenchantment with the Revolution, Diaghilev realized that he would never return to Russia. Then, with the failure of his production of Tchaikovsky's *The Sleeping Princess* (1921) he retreated from

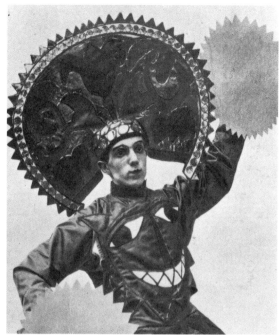

ILL. 29 LÉONIDE MASSINE, NATALIA GONTCHAROVA, MIKHAIL LARIONOV,
IGOR STRAVINSKY AND LÉON BAKST IN SWITZERLAND, 1915.
PHOTOGRAPH BY H. PERRET. COLLECTION OF THE AUTHOR

ILL. 30 LÉONIDE MASSINE IN 'SOLEIL DE NUIT', 1915.
BIBLIOTHÈQUE NATIONALE DE FRANCE, PARIS

Russia. The company found a permanent base
in Monte Carlo. While his choreographers and
most of his dancers, a few composers and several
designers continued to be Russian, he turned more
frequently to European composers and designers.
His productions continued to be innovative
and striking but his interest in ballet began to
wane. It was supplanted by a new enthusiasm.
He devoted the few remaining years of his life
to making a collection of rare Russian books[38]
which he hunted down with meticulous zeal.
Diaghilev died in Venice on 19 August 1929 aged
fifty-seven, and with him died the Ballets Russes.
In his death he crossed that delicate bridge
between West and East for the last time. Although
he had become European, his death on water had
been foretold by a Russian gypsy.

DIAGHILEV AND THE EIGHTEENTH CENTURY

John E. Bowlt

'In art we are now living through all ages and all nations; the art of the past races past us. This is because we are standing before a great future.'[1] That is how the poet and philosopher, Andrei Bely (pseudonym of Boris Bugaev), described the cultural spectrum of the Russian *fin de siècle*. Colleague of Alexandre Benois and Sergei Diaghilev within the *Mir Iskusstva* – 'The World of Art' – magazine and sitter for Léon Bakst and Konstantin Somov, Bely was well aware of the eclecticism of his age, of its extraordinary diapason of ideas and disciplines.

Certainly, when, a century later, we look back at the creative accomplishment of the Russian Symbolists, it is clear that Sergei Diaghilev and his circle championed many faiths in their urgent search for a genuine artistic refurbishing. Diaghilev said as much in his celebrated speech, entitled 'At the Hour of Reckoning', which he delivered after the opening of his *Historical Art Exhibition of Russian Portraits* in 1905:

> Do you not feel that the long gallery of portraits
> of people great and small ... is but a grand
> and convincing reckoning of a brilliant, but,
> alas, mortified, period of our history?... We
> are the witnesses of a great historical moment
> of reckoning and ending in the name of a new,
> unknown culture.[2]

In other words, Diaghilev and his colleagues were not only aware of the impending transmutation and demise of Imperial Russia (and all regarded the Russo-Japanese War and the First Revolution as harbingers of the final catastrophe), but were also, not without desperation, looking to past epochs for some kind of corroborative cultural flowering

that could be noted and perhaps emulated, among them the late seventeenth and eighteenth centuries. Two of Diaghilev's early triumphs – his de luxe catalogue of Dmitri Levitsky's portraits and his supervision of the *Historical Art Exhibition of Russian Portraits* at the Tauride Palace in St Petersburg – are primary examples of this retrospective focus.

Of course, the artistic culture of the eighteenth century was only one of many strong interests within the World of Art and the specific enquiry of this essay is not intended to exaggerate one tendency at the expense of another or to upset customary appreciations. After all, the World of Art was a catholic mix of styles and attitudes; it was, as Benois himself admitted, 'not this, that or the other in isolation, but everything together'.[3] According to Dmitri Filosofov, Diaghilev's cousin and literary factotum of the journal *Mir Iskusstva*, therefore, the group examined 'everything': 'Gainsborough and Beardsley, Levitsky and Briullov, Velázquez and Manet, German woodcuts of the sixteenth century and Goya's prints, steel engravings and lithographs of 1830, Orlovsky's sketches and those of Daumier'.[4]

In any case, the concern with the eighteenth century identifiable with the journal, the exhibitions and other endeavours of *Mir Iskusstva* is only one stratum in its historical repertoire, for a primary hope was to create a new artistic code through the recognition and rediscovery of bygone cultures in general. Diaghilev, for example, identified the apogees of civilization with 'Egypt, Greece and the Middle Ages' and the gods of his age as 'Giotto, Shakespeare and Bach'.[5] Bakst was passionate about Egypt, Greece and the Orient, Benois and Somov were drawn to the

ILL. 31 KUNSTKAMMERA, ST PETERSBURG, 1718–34. ARCHITECTS:
G. J. MATTARNOVI, N. F. GERBEL, G. CHIAVERI, M. G. ZEMTSOV

ILL. 32 ANICHKOV PALACE, ST PETERSBURG, 1741–50.
ARCHITECTS: MIKHAIL ZEMTSOV AND BARTOLOMEO RASTRELLI. ENGRAVING
BY I. VASILEV AFTER A DRAWING BY M. MAKHAEV

epoch of Versailles, Alexander Golovin and Natalia Gontcharova looked to the traditions of Spain, while Mstislav Dobuzhinsky, Eugene Lanceray and Anna Ostroumova were captured by the charm of eighteenth- and early nineteenth-century St Petersburg (ill. 31). Moreover, the retrospective tendency of the World of Art was not confined to the praise of canonical legacies such as the culture of Classical Greece. A profound interest in popular myth and in the primordial state of man also occupied artists such as Nicholas Roerich and Mikhail Vrubel whose paintings, such as *Adoration of the earth* (1912) and *The demon cast down* (1902), respectively, were often regarded as embodiments of an archaic and cohesive strength so lacking in the disrupted society of pre-Revolutionary Russia.

The World of Art is celebrated for its promotion of Symbolism, of the applied arts and Art Nouveau and for the many critical and didactic services that it rendered in the form of publications, exhibitions, concerts and conferences, much of which nurtured perhaps its greatest monument – the Ballets Russes. Even so, among a myriad of artistic interests, the painting and architecture of Russia's eighteenth century played a vital role (ill. 32), informing, for example, many of Diaghilev's activities – and without adequate study of that role, the complex mosaic of the World of Art cannot be fully understood. Not that there was a uniform concordance of interpretations among the *miriskussniki* (as *Mir Iskusstva*'s members were called) on the value and significance of the seventeenth and eighteenth centuries. To Benois and Somov, the Versailles of Louis XIV was magnificent in its solar incandescence and yet their pictures often present the French emperor

and his courtiers as marionettes, lilliputian automatons rather than architects of a cultural renaissance. Paintings such as *The bath of the marquise* (Benois, 1906; cat. 44) and *The letter* (Somov, 1896; cat. 34) or Somov's titillating illustrations to the several editions of *Le Livre de la Marquise* testify readily to this conception of Versailles as both regal playground and den of iniquity.[6] Also relevant to the Versailles connection is the fact that Bakst made his début as an independent scenic painter with his rococo pavilion and period costumes for Marius Petipa's production of *Le Cœur de la Marquise* at the Hermitage Theatre in 1902.

Actually, within the context of the World of Art, the ensemble of Versailles was the prefigurement of Russia's eighteenth century and it left a profound imprint on the World of Art's aesthetic undertakings. After all, the very first ballet that Diaghilev presented to Paris audiences at the beginning of his 'Saisons russes' in 1909 was not *Petrouchka* or *Schéhérazade*, but *Le Pavillon d'Armide* (with Vaslav Nijinsky's first ballet appearance in the West). *Le Pavillon* provided Benois with a theme requiring both a childish simplicity and a precise historical sense, each detail receiving the utmost scrutiny:

> The colour of a braid, of a galloon on the dress of an extra which you couldn't even make out on stage through your binoculars – Benois gave much thought to these things and selected them after careful consideration. He wished the galloon to shine – but not too much. He didn't want 'cheap' flashiness.[7]

ILL. 33 CATHERINE PALACE, TSARSKOE SELO, 1744–56. ARCHITECT: BARTOLOMEO RASTRELLI

Throughout his life Benois returned again and again to the subject of Versailles both as designer and as author.[8]

True, the ambiance of *Le Pavillon d'Armide* is of the later seventeenth century and may seem to have little in common with Russian culture, but Diaghilev's selection of the ballet as his signal piece and Benois' elaborate decorations for the sets and costumes indicate that the French seventeenth century carried a peculiarly 'indigenous' inflexion, too. Its grotesque and conclusive pomposity of galas, fireworks, balls and amorous digressions must have evoked comparisons with the descent of Imperial Russia, a haunting, twilight zone that also permeated Benois' illustrations for Alexander Pushkin's *Queen of Spades*[9] and, much later, Alexandre Sérébriakoff's renderings for the Bal Costumé organized by Charles de Beistegui at the Palazzo Labia in Venice in 1951.

There is evidence to assume that, to Diaghilev and his colleagues, Russia's architectural boom of the eighteenth century (the founding of St Petersburg in 1703 and the construction of suburban palaces such as Petergof and Tsarskoe selo, ill. 33) was Russia's response to the splendour of Versailles, an analogy that Benois seemed to capture in paintings such as *Peter the Great walking in the*

Summer Garden (1910) and *Catherine the Great making her entry into the palace at Tsarskoe selo* (1909). Perhaps on a more private note, Benois' delight in the confectionery of Versailles mirrored a homage to his eighteenth-century French ancestor, Louis Jules Benois, chef to Emperor Paul I, while Diaghilev boasted an even loftier lineage, arguing that his large head and feet derived from a familial connection with Peter the Great.

True, the World of Art makes reference to numerous representations of eighteenth-century European culture – the portraiture of Gainsborough, the caricatures of Hogarth, the painting of Watteau – but the immediate parallels between, say, Petergof (commissioned by Peter the Great in 1709) and Versailles are striking and uncanny: both ensembles vaunt the triumph of hydraulic and horticultural sciences over the vagaries of nature (ill. 34); both emphasize rational and geometric imposition; both exploit the reflective surfaces of water, marble, mirrors, and chandeliers; and both, as *Gesamtkunstwerke*, function as gigantic theatres for festivity and spectacle. The culture of Versailles in particular and the culture of the Russian eighteenth century in general were both, as Pavel Muratov observed, 'magical decorations'.[10]

All this is to say that to Diaghilev the eighteenth

ILL. 34 PALACE AND GRAND CASCADE OF PETERGOF. ARCHITECT: BARTOLOMEO RASTRELLI

century, which, to all intents and purposes, meant the St Petersburg of Peter the Great (r. 1682–1725), Elizabeth I (r. 1741–61) and Catherine the Great (r. 1762–96), represented Russia's humanistic renaissance: it possessed a recognizable style, an ideological and aesthetic purposefulness, a subtle artistry, an international stance and the volition of enlightened, if not always benign, dictators – qualities that, in the nineteenth century, gave way to derivativeness, parochialism and academic routine. As Diaghilev asserted in his lead article for *Mir Iskusstva* in November 1898: '[the nineteenth century] consisted of a mosaic of contradictory directions, all of the same value'.[11]

Arguing that the nineteenth century had lacked technical prowess and ignored formal beauty, Diaghilev and Benois now professed the urgent need to recapture the mastery and artisanship of the Russian eighteenth century. To World of Art artists such as Elizaveta Kruglikova, Ivan Bilibin, Bakst, and Somov, art forms like the silhouette, book illustration, stage design and even embroidery and bead-work required reasoned imagination and formal control, salient features that they identified, in turn, with the artistic culture of Russia's eighteenth century. Finally, the World of Art accused the nineteenth century of 'vandalizing'

much of Catherine's cultural legacy by changing, demolishing or simply neglecting architectural monuments such as the Mikhailovsky Palace in St Petersburg;[12] and Diaghilev himself was quick to criticize the newly established Museum of Alexander III in St Petersburg (now the State Russian Museum) for disregarding eighteenth-century Russian portraiture.

Such vociferousness encouraged a veritable campaign to promote and save Russia's eighteenth-century heritage in the specialist journals *Khudozhestvennye sokrovishcha Rossii* [Art Treasures of Russia] (St Petersburg, 1901–03) and *Starye gody* [Bygone Years] (St Petersburg, 1907–16). Both of these journals, edited by Benois, attracted a number of perspicacious historians and collectors such as Georgy Lukomsky, Nikolai Vrangel', and Alexander Trubnikov, who contributed essays on painting, architecture, the decorative arts and material culture. Benois identified his editorial mission as follows:

> We believe that the forms which once upon a time grew naturally from the Russian soil are closer to the Russian heart.... However, to cease being a European now, to shelter from the West behind a wall, would be odd, even absurd.... That is why, alongside works of our

own national art, we will not fear to present all things foreign and European preserved within the borders of Russia.[13]

These sentiments demonstrate that, for the *miriskussniki,* Russia's eighteenth century meant even more than the grandeur of Catherine's 'painterly St Petersburg'.[14] It also denoted the 'genuine magic'[15] of Russia's first professional portrait painters such as Aleksei Antropov, Ivan and Nikolai Argunov and Dmitri Levitsky (ills. 35, 36), the modest Classical buildings of pre-Napoleonic Moscow, the noble knick-knacks of snuffboxes, teacups, fans and miniatures (collected, depicted and copied by Somov) and the hieratic rituals that accompanied the ambassadorial reception, the grand ball (cf. Somov's *Carnaval,* 1913) and the royal hunt.[16] The chinoiserie of the eighteenth century returns in Benois' fanciful *Chinese Pavilion* (1906), in his designs for Diaghilev's production of *Le Rossignol* (1914; cat. 126) and in his essay on the Chinese Palace at Oranienbaum.[17] Some of the publications on these aspects of the eighteenth century by the apologists of the World of Art remain even to this day primary sources of documentary information and aesthetic appreciation. There are several key circumstances, physical and psychological, that help to explain Diaghilev's own sympathy for the eighteenth century. The year of 1903 marked the bicentennial celebrations of the founding of St Petersburg and the World of Art supported the event by publishing several articles on the architecture of St Petersburg and the surrounding complexes, such as Monplaisir and Tsarskoe selo (ill. 38). The World of Art circle, from its earliest manifestation as the Society of Nevsky Pickwickians in the early 1890s to its last

ILL. 35 DMITRI LEVITSKY, THE WRITER NIKOLAI NOVIKOV, 1797. STATE TRETIAKOV GALLERY, MOSCOW

titled exhibition in Russia of 1924, was firmly rooted in St Petersburg/Leningrad. Most of the initial members, such as Benois, Walter Nouvel and Somov, were from St Petersburg (the notable exception being Diaghilev), and the guiding artistic and critical force, Benois, hailed from a family steeped in the 'historical sentimentalism'[18] of the traditional St Petersburg intelligentsia: fluency in French and German as well as Russian, enormous library, collection of prints and sepias, eighteenth-century furniture, visits to museums and theatres and frequent excursions to Pavlovsk and Petergof.

In turn, this wider recognition of the pioneering culture of Russia's eighteenth century, when suddenly the European community sat up and took notice of its neighbour to the East, generated an inevitable nostalgia in the Russian public at large for the ruthless discipline of Peter and the pomp and circumstance of Catherine – at a time of war, revolution and political uncertainty. Autocratic and obdurate by nature, Diaghilev also admired the oligarchic gestures of Peter and Catherine which, sustained by unlimited material resources and unswerving belief in the destiny of Russia, could establish a new capital on a northern marsh, import German and British order to create a Russian army and navy and build one of the greatest art collections in the world (now in the Hermitage). Like Peter and Catherine, Diaghilev also exercised an autocratic prerogative in his selection of artists and works of art, dancers and repertoires, lovers and friendships. Self-confident and ambitious, Diaghilev had no qualms in attaching his name or signature to endeavours that promoted his own talent or taste: as early as 1895 he proposed founding a national gallery 'in his own name',[19]

he ordered his clothes from Savile Row, and he dyed his forelock silver to affect wisdom and maturity. But like his regal 'role models', Diaghilev was not immune to the foibles of mood and sensual gratification, rewarding or dropping friends and lovers, plotting the overthrow of a rival or currying favour with those in power. Similarly, Diaghilev felt that cultural expansion and social interaction, not insularity, gave rise to artistic regeneration and, just as the monarchs had invited British, Dutch, French, German and Italian artists and artisans to build the new Russia, so Diaghilev ensured that his first exhibitions were international in scope, that *Mir Iskusstva* was printed in Russian and in French and that the achievements of modern Russian art, music and dance were exported to Paris, Berlin and London. But for all this cosmopolitan gloss, Diaghilev, like Peter the Anti-Christ and Catherine the German Princess, was 'totally Russian'[20] and never doubted the potential of his native country or the validity of his own, pre-ordained mission. Peter and Catherine or, rather, the eighteenth century in general, appealed to Diaghilev precisely because they had countenanced the subtle interchange of public propriety and private caprice, while observing strict divisions between social duty and personal quirk. They also professed an evident belief in the need for solidity both of social structure and of practical technique – and both conditions inspired Diaghilev to turn to Russia's aristocratic portraiture of the late eighteenth century and to direct considerable time, energy and financial resources to the study and promotion thereof.

A graduate from the Law School at St Petersburg University, an aesthete and a *charmeur,* Diaghilev had no art-historical qualifications. But in matters of aesthetic judgement and jurisdiction, he was

ILL. 36 DMITRI LEVITSKY, PORTRAIT OF URSULA MNISZECK, 1782.
STATE TRETIAKOV GALLERY, MOSCOW

an amateur in the original sense of the word, possessed an unfailing 'eye' for recognizing the merits of a work of art and exercised impeccable taste. Although he did publish a number of articles and reviews concerning the visual arts, they tended to be narrative, often brusque and sometimes cantankerous – rather than 'formal' or 'aesthetic'. Rarely did Diaghilev write about the colour, texture or composition of the work of art; rather, he emphasized historical importance, stylistic unity and provenance, qualities that guided his selections both for the monograph on Levitsky and for the exhibition of portraits at the Tauride Palace. His research on lesser-known artists such as Mikhail Shibanov[21] derived particular benefit from this kind of straightforward documentary approach and protocolic assessment.

As far as the Levitsky monograph is concerned, the design, clearly, was intended to repeat that of an elegant eighteenth-century edition. Bakst's gallant frontispiece, Somov's 'rococo' vignettes, the heavy leather binding and the rice-paper inserts make *Levitsky* a superb example of the antique fine edition and, *horribile dictu,* perhaps it is of greater value as such than as a scholarly analysis.

From the late spring of 1901 until the end of 1902 Diaghilev spent most of his time abroad visiting exhibitions, museums and studios. Absence from Russia enabled him to form a more objective judgement of Russia and to appreciate in full the positive and negative sides of modern Russian culture. As he told Benois, 'while sitting in the marsh, I'm not really capable of writing about the marsh'.[22] During this period Diaghilev devoted much time and energy to Russian antiquity, adding to his collection of materials for a proposed documentary account of eighteenth-century Russian art in general and for individual monographs on the distinguished

portrait painters Vladimir Borovikovsky (ill. 37), Dmitri Levitsky, Feodor Rokotov and Ivan Argunov. Diaghilev described his project in a letter that he sent to the newspaper *Novoe vremia* [New Time] in 1901:

> January of next year [1902] will see the publication of the first volume of *Russian Painting in the Eighteenth Century*. This illustrated edition is my undertaking and the entire work will consist of three volumes. The first is devoted to the works of D. G. Levitsky, the second to the portrait painters of the second half of the eighteenth century (Rokotov, Antropov, Drozhzhin, Shibanov, Argunov, Shchukin et al.) and the third to V. L. Borovikovsky.
>
> Inasmuch as the majority of the works of the above-mentioned painters are in private hands, I am appealing – through your esteemed newspaper – to all owners of pictures and portraits by these artists to inform me of any works that they might have (St Petersburg, Fontanka 11). The articles on the artists will be written by V. P. Gorlenko and A. N. Benois. The aim of the edition is to bring together materials – scattered and ill researched – relating to remarkable Russian artists as well as to provide good-quality photographs of their works.[23]

At the end of 1901 the first (and only) volume – on Levitsky – was being advertised as forthcoming and it was published in St Petersburg in February 1902. Essentially, Diaghilev's *catalogue raisonné* was a comprehensive source of curatorial information and a masterpiece of polygraphy – one of the most prestigious productions of the Society of the Printing Arts in Russia. Still, in this respect *Levitsky* was not totally without immediate precedents, for it drew upon the practical experience of the *Mir Iskusstva* magazine and also reinforced the artistry and elegance of design found in the *Ezhegodnik imperatorskikh teatrov* [Annual of the Imperial Theatres] that Diaghilev had compiled and published a few months earlier. In some sense, Diaghilev's *Annual* for 1901 may also be regarded as a homage to the aesthetic measure of the eighteenth century and, certainly, it serves as an important precedent to the Levitsky monograph. Commissioned by Prince Sergei Volkonsky, then Director of the Imperial Theatres, Diaghilev 'decorated' the *Annual* with vignettes

and filigrees in the manner of the eighteenth-century fine edition, transforming what had been a rather pedantic directory into a bibliophilic *rarité* with novel and luxurious format. As with *Mir Iskusstva*, Diaghilev also viewed his *Annual* as a collective enterprise, inviting Bakst to design the cover and Somov to take responsibility for the head- and tailpieces. Diaghilev also made sure to include colour reproductions of some of the programmes designed by Bakst and Somov for the Hermitage Theatre and lithographic portraits of Ivan Vsevolozhsky, the previous Director of the Imperial Theatres, the composer Alexander Glazunov and other luminaries. In addition, he asked his World of Art friends (especially Bakst) to touch up and improve the photographs of celebrities; he commissioned an article from the ballet critic Valerian Svetlov on 'Choreography in Classical Times' and a short note by Benois on the Alexandrinsky Theatre. Last, but not least, Diaghilev compiled a detailed list of all ballets performed at the St Petersburg Imperial Theatres between 1828 and 1900. Both technically and academically, the *Annual* provided him with invaluable experience for his concurrent compilation and supervision of the Levitsky catalogue.

Although the major portion of *Levitsky* was Diaghilev's responsibility, the descriptive introduction was written by a minor historian, Vasilii Gorlenko – which has prompted some observers, not least Michel Fokine, to intimate that the Levitsky monograph was, therefore, an impressive example of Diaghilev's organizational ability, but not of creative talent. Whether there is any truth in such an assumption or not, it must at least be qualified by reference to Diaghilev's many other critical and, therefore, creative contributions to newspapers and journals of the same period. Unfortunately, Diaghilev was too busy with his numerous enterprises to spend much time writing, because, as Bakst remarked with some irritation, 'he didn't answer letters, he led people by the nose, he was always in a hurry'.[24]

Diaghilev's *Levitsky* was one of several 'eighteenth-century' de luxe editions that the *miriskussniki* produced and which, if assembled, would in themselves make for an elegant exhibition and useful catalogue. Benois' study of *Tsarskoe selo v tsarstvovanie imperatritsy Elizavety Petrovny* [Tsarskoe selo during the Reign of Empress Elizaveta Petrovna], published by Golike and

ILL. 37 VLADIMIR BOROVIKOVSKY, PORTRAIT OF M. I. LOPUKHINA, 1797. STATE TRETIAKOV GALLERY, MOSCOW

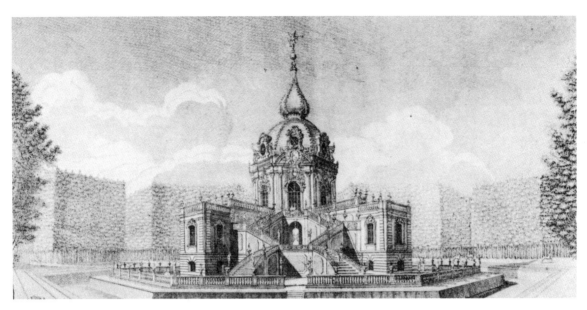

Vilborg in 1910, for example, is a splendid tribute not only to the foresight of Elizaveta Petrovna and to Catherine's resolve, but also to the genius of Charles Cameron – and served as a basis for other, subsequent investigations into the subject such as Lukomsky's *Tsarskoe selo* (Munich 1923) and *Charles Cameron* (London 1947). Moreover, with its heavy paper, quality reproductions of plans and engravings, gold-embossed Moroccan binding, and Somov's subtle frontispiece, Benois' *Tsarskoe selo*, like Diaghilev's *Levitsky,* marks a highpoint in the history of Russian book design.

Undoubtedly, the finest and conclusive expression of Diaghilev's attraction to the eighteenth century was his grandiose *Historical Art Exhibition of Russian Portraits*. Opening in March 1905 at the Tauride Palace in St Petersburg, this exhibition was, indeed, a reckoning not only of a major Russian artistic accomplishment, but also of Diaghilev's life in Russia – thereafter he lived predominantly in France and Italy.

Diaghilev planned his exhibition to be grander, more discerning and more accurate than the exhibition which Baron Vrangel had arranged in 1902 at the Academy of Sciences in St Petersburg, i.e. 'Russian Portrait Painting of the Last 150 Years'. Although Diaghilev and Benois had been involved in the enterprise, Diaghilev criticized the result in rather harsh terms, referring to its 'poor accommodation and fortuitous composition' and contending that a 'dozen guys put together the things they liked and made an exhibition'.[25] In part, no doubt, Diaghilev's severity stemmed from his annoyance at the fact that his own idea had been anticipated and that since private collectors 'will not lend every day',[26] his own exhibition (which he was already contemplating) might be compromised. Even if Diaghilev was justified in highlighting the several mistakes in attribution (at least two of the 'Borovikovskys' were by Johann Lampi, for example), Vrangel's exhibition did indicate a growing, serious interest in the Russian eighteenth century among scholars and collectors. In turn, it intensified a public curiosity about the epoch of Catherine the Great already piqued by the successful, although eclectic, *Exhibition of Antique Works of Art* held at the Stroganov Institute in Moscow in April 1901. Obviously, the moment for a definitive exhibition of the portraitists of old Russia was opportune, for 'they startle you, they root you to the spot. Russia has almost no need to envy England and Reynolds, Gainsborough, etc.'[27]

Throughout 1904 Diaghilev travelled extensively in Russia and Europe, searching for portraits in forgotten palaces and estates and borrowing from collections in Paris, Vienna, Berlin, Amsterdam, Weimar and Geneva. The outcome was his spectacular *Historical Art Exhibition of Russian Portraits*, which, with a generous subsidy from Emperor Nicholas II, opened in the Tauride

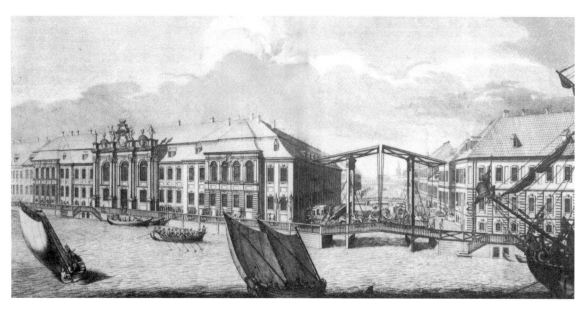

ILL. 39 SECOND WINTER PALACE, ST PETERSBURG, 1716–24. ARCHITECTS: GEORG JOHANN MATTARNOVY AND DOMENICO TREZZINI.
ENGRAVING BY E. VINOGRADOV AFTER A DRAWING BY M. MAKHAEV

Palace, St Petersburg, in February 1905 – to the strikes and demonstrations of the First Russian Revolution. With a complement of 4,000 canvases including thirty-five portraits of Peter the Great, forty-four of Catherine the Great and thirty-two of Alexander I, with long-forgotten works by Borovikovsky, Levitsky and Rokotov and with a scholarly catalogue in eight separate volumes compiled by Vrangel, the exhibition was, in itself, a historic event and, for all practical purposes, was the last time that such an assemblage was feasible. The significance of Diaghilev's Russian portraits exhibition for the understanding of Russian art and social history was of the utmost importance, as Igor Grabar recalled:

> With the Diaghilev exhibition there begins a new era in the study of Russian and European art of the eighteenth century and the first half of the nineteenth. Instead of obscure bits of information and unverified data, one could now, on the basis of this huge amount of material gathered from the four corners of Russia, establish new facts, new sources, new interrelationships and common influences in the history of art. This led to dramatic and, in some respects, unexpected re-evaluations which clarified much of what, thitherto, had not been understood and which revealed new, alluring horizons for future, intensive study.[28]

Between February and May, the date of its closure, 45,000 visitors saw the exhibition and its philanthropic mission 'for the benefit of widows and orphans of those fallen in battle' (i.e. in the Russo-Japanese War) was profitable to the tune of 60,000 rubles. The exhibition drew people not only because of what it displayed, but also because of Benois' and Lanceray's efficient installation, Lanceray's tasteful poster and Bakst's charming Winter Garden. Benois described the general layout:

> The effect was greatly enhanced by the way in which the most important portraits were grouped together. In the centre of each group, under a special canopy, hung the portrait of the emperor or empress indissolubly identified with the epoch. Seriozha [Diaghilev] and I were responsible for the grouping and the distribution of the innumerable masses of exhibits, while Bakst had been entrusted with the arrangement of the 'Winter Garden' wherein stood the most important sculptures, a task which he had accomplished with much success. The green trellis occupying the middle of the colossal colonnade and the hot-house plants brought from the Imperial conservatories formed an enchanting background for the white marble statues, immortalising eminent statesmen, soldiers and wealthy magnates, as well as court ladies and favourites.[29]

The social and cultural effect of the exhibition was profound. According to Sergei Makovsky, the exhibition stimulated a craze in St Petersburg for collecting ancestral portraits;[30] it caused Konstantin Stanislavsky to transfer the historical setting of his production of Hauptmann's *Schluck and Jau* at the Moscow Art Theatre from the Middle Ages to the eighteenth century; and for the first time many sensed the 'great skill of Levitsky, the extraordinary gift of Rokotov, the charm of Borovikovsky, and the mastery of Kiprensky and Briullov'.[31] It is also tempting to assume that Serov's exposure to these remarkable portraits of the powerful and the wealthy informed and encouraged his own focus on the imperious salon portrait, as in his likenesses of Nicholas II (1896), Princess Zinaida Yusupova (1902) and Olga Orlova (1910). Open during the tragic events of the 'dress rehearsal for 1917', the Tauride Palace exhibition was a visual metaphor for the brilliant majesty of an era long passed, one that 'exuded the might and power of land-ownership and the full-dress uniform'.[32]

After the Tauride undertaking, Diaghilev turned his sights to Western Europe and within a short time was amazing Paris with his new ballet company. He now directed his energies towards hiring dancers, commissioning composers, and finding sponsors for spectacles such as *Petrouchka* and *Le Sacre du printemps* that had little to do with the Imperial culture of Russia's eighteenth century. Occasionally, of course, Diaghilev revisited that era, sometimes indirectly, by staging ballets such as De Falla's *Le Tricorne* (1919) with Picasso's scenes of eighteenth-century Granada; Cimarosa's *Les Astuces féminines* (1920), with its mélange of eighteenth-century Naples and Russian folk dances; or *Ode* (1928), with its homage to Mikhail Lomonosov. Diaghilev also continued to assuage his collecting appetite by concentrating on rare eighteenth-century books and manuscripts. But in emigration a key ingredient was missing – the city of St Petersburg with the profile of its architecture and the refraction of its waterways (ill. 39). In the old days, the very fabric of that city had reminded Diaghilev constantly of the artistic freshness of Russia's eighteenth century, but now, however beautiful, the jaded metropoles of Paris, Berlin, London and New York could not replace the magic light and duplicit grace of Diaghilev's 'Venice of the North'.

PAINTING

Although most of the artists associated with Diaghilev owed their fame to their theatrical designs, painting played a decisive role in the early years of *Mir Iskusstva* and in the exhibitions Diaghilev organized from 1896 onwards. It was a period in which portrait-painting flourished, while a number of artists were busy experimenting with form, colour and composition – some inspired by French examples, others adopting an entirely personal approach. The paintings of the French-trained Victor Borisov-Musatov, for instance, are full of transience, nostalgia and symbolism (cat. 4–6), with references to the work of Puvis de Chavannes and Maurice Denis. Mikhail Vrubel and Valentin Serov, meanwhile, were two older, established artists who were closely involved with *Mir Iskusstva* from the outset. Vrubel's highly individual paintings won him considerable admiration from the younger generation. His *Lilacs* (1900; cat. 40), for instance, highlights the modernist preoccupation with pure form, colour and composition within a two-dimensional plane, at the expense of a realistic sense of depth and use of colour. The deformed, sculptural figure of Savva Mamontov in the portrait Vrubel painted in 1897 looks forward to the formal experiments of Cubism (cat. 39).

Valentin Serov, a child prodigy at drawing, was taken on as a pupil by the painter Ilya Repin at the tender age of six. His monumental portraits of Mikhail Morozov and bass singer Feodor Chaliapin (cat. 30) are masterpieces of late-nineteenth-century portraiture. Léon Bakst's likeness of Liubov Gritzenko and Serov's of Nikolai Pozniakov (cat. 2, 31), meanwhile, convey the atmosphere of gloom, decadence and morbidity that so typify the *fin de siècle*. The highly individual Konstantin Somov also played an important part in the group around Diaghilev. His early paintings feature hushed scenes set in parks in an idealized past (cat. 34–36). Somov frequently experimented with unusual perspective, as we see in his 1897 painting *Confidences* (cat. 35).

The artist couple Mikhail Larionov and Natalia Gontcharova developed their artistic careers outside the Petersburg group. Diaghilev invited them to come and work for the Ballets Russes in 1913. The influence of the French Fauves was plainly apparent in their paintings prior to their departure for Paris, as, above all, was that of Russian primitive folk art (cat. 9–10, 17–19). The images of Spanish dancers and folkloric motifs that Gontcharova went on to paint in France (cat. 11–16) reflect the intense interest shown by the Ballets Russes in Spanish themes – a taste that originated in turn-of-the-century Russia, as illustrated by Vrubel's monumental *Spain* (1894; cat. 38) and Golovin's many theatrical designs (cat. 130–37).

52

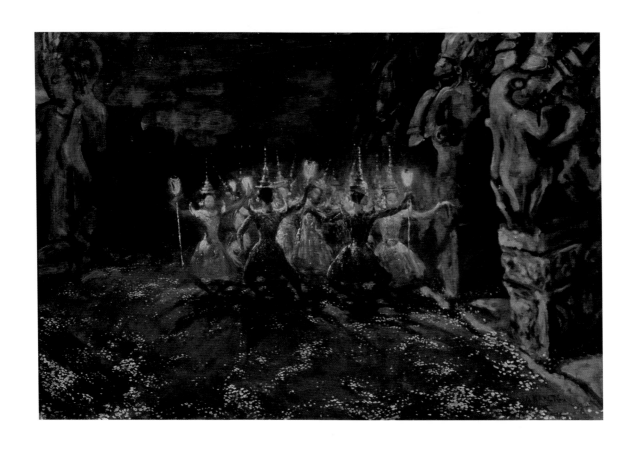

➤1➤
Léon Bakst - Siamese sacred dance 1901

STATE TRETIAKOV GALLERY, MOSCOW

Léon Bakst - Portrait of Liubov Gritzenko 1903

STATE TRETIAKOV GALLERY, MOSCOW

━3━
Léon Bakst - Set design for Hélène de Sparte 1912

Victor Borisov-Musatov - Lady in a rocking chair 1897
STATE TRETIAKOV GALLERY, MOSCOW

Victor Borisov-Musatov - Harmony 1900
STATE TRETIAKOV GALLERY, MOSCOW

Victor Borisov-Musatov - Garlands of cornflowers 1905

<div align="center">

⋆7⋆

Alexander Golovin - Feodor Chaliapin in the role of Boris Godunov 1912

STATE TRETIAKOV GALLERY, MOSCOW

</div>

❖8❖

Alexander Golovin - *Overgrown swamp* 1917

STATE TRETIAKOV GALLERY, MOSCOW

Natalia Gontcharova - Peasants setting potatoes 1907

STATE TRETIAKOV GALLERY, MOSCOW

◄10►
Natalia Gontcharova - Peacock 1910
STATE TRETIAKOV GALLERY, MOSCOW

Natalia Gontcharova - Spanish woman with fan 1919–20

STATE TRETIAKOV GALLERY, MOSCOW

Natalia Gontcharova - Spanish woman with fan *c.* 1920

Natalia Gontcharova - Spanish woman *c.* 1920–24

CENTRE GEORGES POMPIDOU, PARIS

Natalia Gontcharova - Spanish woman *c.* 1920–24

CENTRE GEORGES POMPIDOU, PARIS

◆15◆
Natalia Gontcharova - Two Spanish women 1920s
STATE TRETIAKOV GALLERY, MOSCOW

◄**18**►
Mikhail Larionov - Smoking soldier 1910–11

STATE TRETIAKOV GALLERY, MOSCOW

Zinaida Serebriakova - Dressing room for Peter Tchaikovsky's 'Swan Lake' ballet 1924

STATE TRETIAKOV GALLERY, MOSCOW

◄24►
Zinaida Serebriakova - Les Sylfides (Chopiniana ballet) 1924
STATE TRETIAKOV GALLERY, MOSCOW

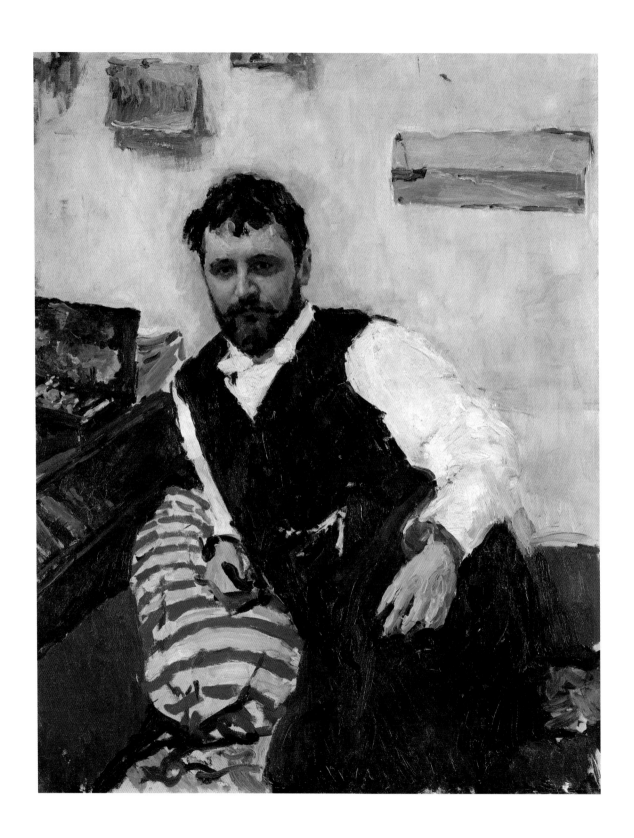

Valentin Serov - Portrait of Konstantin Korovin 1891

STATE TRETIAKOV GALLERY, MOSCOW

Valentin Serov - The composer Nikolai Rimsky-Korsakov 1898
STATE TRETIAKOV GALLERY, MOSCOW

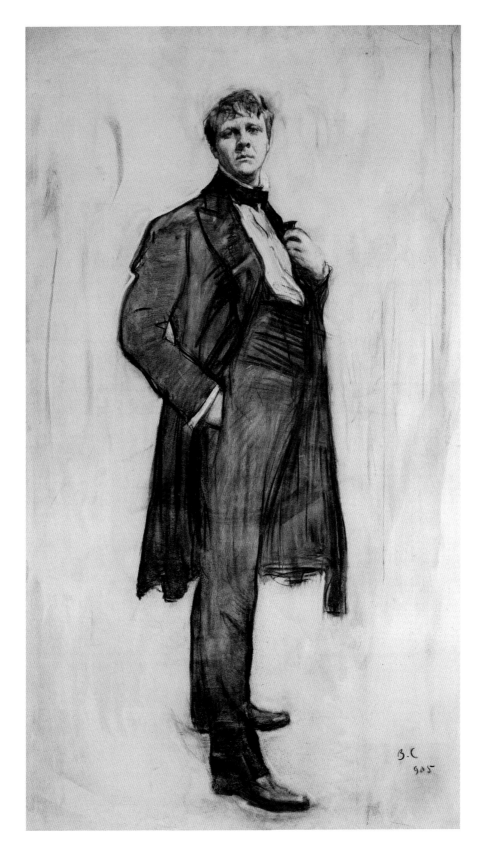

⤙30⤚

Valentin Serov - The singer Feodor Chaliapin 1905

STATE TRETIAKOV GALLERY, MOSCOW

Valentin Serov - Portrait of Nikolai Pozniakov 1908

STATE TRETIAKOV GALLERY, MOSCOW

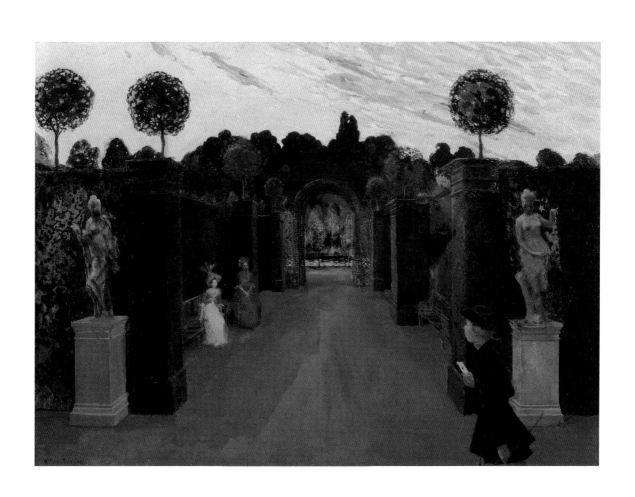

◆34◆
Konstantin Somov - The letter 1896
STATE TRETIAKOV GALLERY, MOSCOW

◄36►
Konstantin Somov - Morning in the park 1899
STATE TRETIAKOV GALLERY, MOSCOW

◄38►
Mikhail Vrubel - Spain 1894

STATE TRETIAKOV GALLERY, MOSCOW

WORKS ON PAPER I

Much of the work produced by the artists associated with Diaghilev was done on paper – etchings, woodcuts, drawings, watercolours and gouaches – reflecting the fact that their principal platform was the magazine *Mir Iskusstva*, for which they supplied numerous illustrations and decorative graphic work. And as they were interested in more intimate, more intellectual and less popular themes than the preceding generation of artists, the fragile and detailed nature of graphic forms seemed better suited.

Alexandre Benois' watercolours and gouaches, such as *The bath of the marquise* (1906; cat. 44), testify to the *Mir Iskusstva* group's fascination for the eighteenth century, which went far beyond any mere historical interest. Instead, works like this were intended as the representation of a perfect dream-world in which harsh reality was banished by beauty and elegance. The choice of subject was also undoubtedly a reaction against the raw naturalism that dominated painting and literature in the latter part of the nineteenth century. Moreover, the quest for worlds of idealized beauty led them to the imagery of the theatre and masquerade, which was explored to one extent or another by virtually all the *Mir Iskusstva* artists. Benois' drawings are exemplified by *A Venetian feast in the sixteenth century* (1912; cat. 46) and *Italian comedy. Love letter* (1905; cat. 43).

Konstantin Somov was the group's most original and productive graphic artist. His work includes an extended series of Harlequins, Pierrots and Colombines, such as *Harlequin and Lady* (1912; cat. 83). The imagery of his detailed and colourful work – full of irony and subdued eroticism – drew on elements from eighteenth-century book illustration and Meissen porcelain. Somov was also a highly gifted portraitist; he decided around 1908 to produce a gallery of portraits of leading figures from the *Mir Iskusstva* group, including the painter Eugene Lanceray, the poet Mikhail Kuzmin and the graphic artist Mstislav Dobuzhinsky (cat. 79–80, 82). Somov was by no means alone in painting portraits of the artists with whom he felt an affinity. There was a general tendency within the group to stress their fellowship by sketching, drawing or painting each other's likenesses.

In the period that he worked for the Ballets Russes in Paris, Mikhail Larionov produced dozens of sketches and cartoons of the artists with whom he worked (cat. 47–61). Valentin Serov, on the other hand, made portraits of Diaghilev's most important dancers, Anna Pavlova and Tamara Karsavina (cat. 69–70). The Russian artists introduced the habit, moreover, to the French and Spanish artists who worked for the group, hence Picasso's masterly series of portraits of Diaghilev, Stravinsky, Satie and Bakst (cat. 64, 66–68).

Léon Bakst - Portrait of Léonide Massine 1914

THE MCNAY ART MUSEUM, SAN ANTONIO

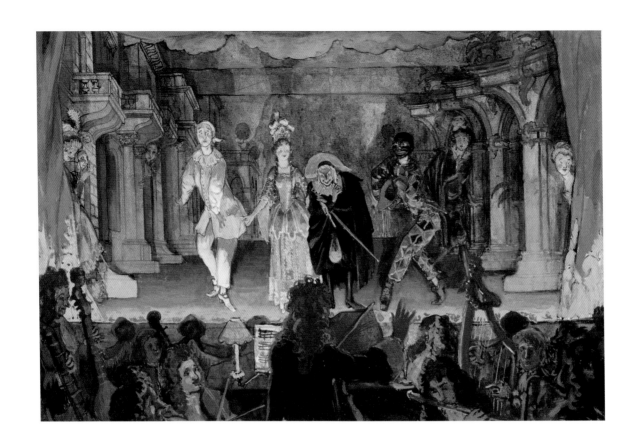

→43←
Alexandre Benois - Italian comedy. Love letter 1905
STATE TRETIAKOV GALLERY, MOSCOW

96

Alexandre Benois - The bath of the marquise 1906
STATE TRETIAKOV GALLERY, MOSCOW

**Alexandre Benois - Stravinsky playing on the piano the music
for 'Petrouchka' in the hall of Teatro Costanza, Rome** 1911
COLLECTION NIKITA AND NINA LOBANOV-ROSTOVSKY, LONDON

◆47◆
Mikhail Larionov - Portrait of Igor Stravinsky *c.* 1915
STATE TRETIAKOV GALLERY, MOSCOW

◆48◆
Mikhail Larionov - Portrait of Natalia Gontcharova 1915
STATE TRETIAKOV GALLERY, MOSCOW

◆49◆
Mikhail Larionov - Sergei Diaghilev with dog 1915–16
STATE TRETIAKOV GALLERY, MOSCOW

◆50◆
Mikhail Larionov - Sergei Diaghilev with flower 1915–16
STATE TRETIAKOV GALLERY, MOSCOW

◆51◆
Mikhail Larionov - Sergei Diaghilev in profile 1915–16
STATE TRETIAKOV GALLERY, MOSCOW

◆52◆
Mikhail Larionov - Portrait of Léonide Massine 1915–16
STATE TRETIAKOV GALLERY, MOSCOW

◆53◆
Mikhail Larionov - Prokofiev, Diaghilev, the artist and
T. Slavinsky during a rehearsal of the ballet Chout 1921
CENTRE GEORGES POMPIDOU, PARIS

◆54◆
Mikhail Larionov - Sergei Diaghilev watching Serge Lifar
and other dancers during a rehearsal 1927
COLLECTION NIKITA AND NINA LOBANOV-ROSTOVSKY, LONDON

◆55◆
Mikhail Larionov -
Diaghilev, Gontcharova, Stravinsky 1930–35
CENTRE GEORGES POMPIDOU, PARIS

◆56◆
Mikhail Larionov -
Diaghilev, Gontcharova, Stravinsky, Prokofiev 1930–35
CENTRE GEORGES POMPIDOU, PARIS

◆57◆
Mikhail Larionov - Portrait of Sergei Diaghilev 1930–35
CENTRE GEORGES POMPIDOU, PARIS

◆58◆
Mikhail Larionov - Caricature of Diaghilev's circle
THE MCNAY ART MUSEUM, SAN ANTONIO

◆59◆
Mikhail Larionov - Portrait of Manuel de Falla
VICTORIA & ALBERT MUSEUM, LONDON

◆60◆
**Mikhail Larionov - Gontcharova, Diaghilev, Massine and
Beppo – Diaghilev's valet – at a café table**
VICTORIA & ALBERT MUSEUM, LONDON

◆61◆
Mikhail Larionov - Diaghilev in profile, to the left
VICTORIA & ALBERT MUSEUM, LONDON

◀62▶
Pablo Picasso - Three dancers 1919

MUSÉE PICASSO, PARIS

63
Pablo Picasso - Seven dancers 1919

Pablo Picasso - The artist's apartment, Rue la Boétie: Jean Cocteau, Olga, Satie, Bell 1919

MUSÉE PICASSO, PARIS

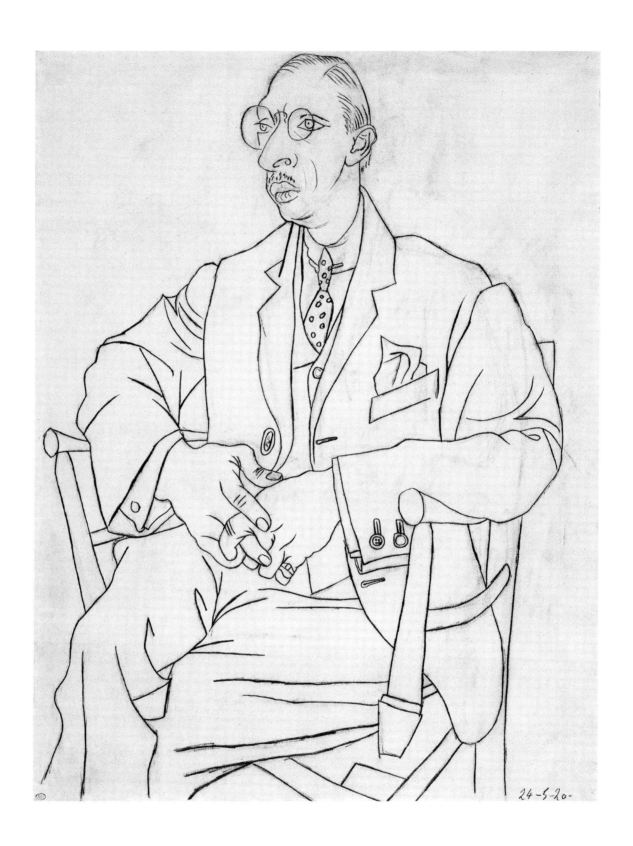

→66←

Pablo Picasso - Portrait of Stravinsky 24 May 1920

MUSÉE PICASSO, PARIS

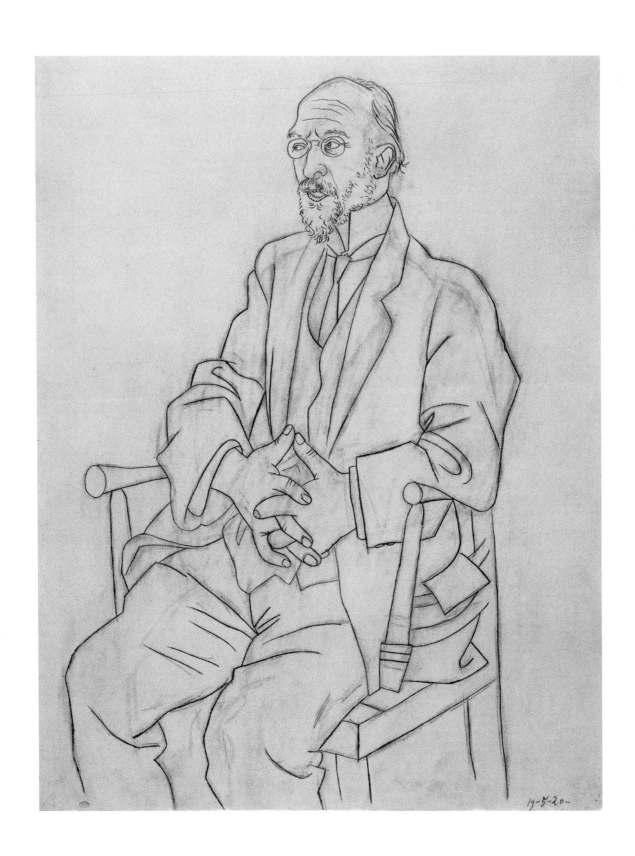

◄67►
Pablo Picasso - Portrait of Satie 19 May 1920

MUSÉE PICASSO, PARIS

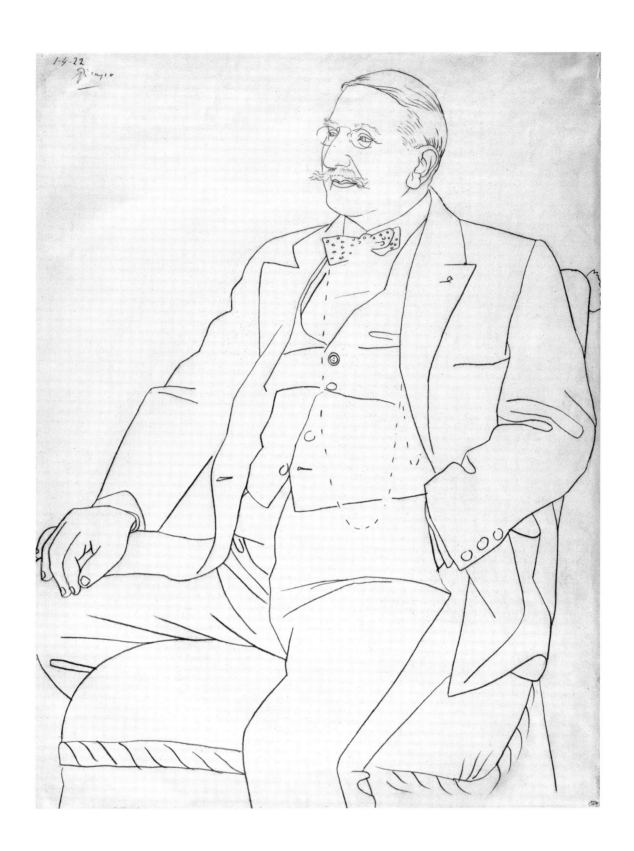

Pablo Picasso - Portrait of Léon Bakst 1922

MUSÉE PICASSO, PARIS

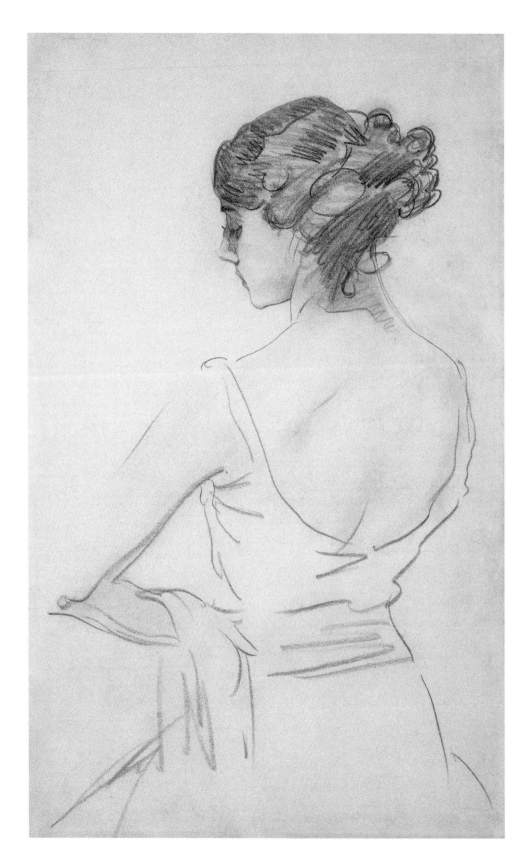

Valentin Serov - The ballerina Alexandra Pavlova 1909

STATE TRETIAKOV GALLERY, MOSCOW

→71←
Valentin Serov - Standing nude 1909–10

STATE TRETIAKOV GALLERY, MOSCOW

→72←
Valentin Serov - Nude seated on a stool 1909–10

STATE TRETIAKOV GALLERY, MOSCOW

112

Valentin Serov - The dancer Ida Rubinstein 1910

STATE TRETIAKOV GALLERY, MOSCOW

+74+
Valentin Serov - Standing nude 1910

STATE TRETIAKOV GALLERY, MOSCOW

+75+
Valentin Serov - Portrait of Vaslav Nijinsky 1910

STATE MUSEUM FOR THEATRE AND MUSIC, ST PETERSBURG

114

Valentin Serov - Odysseus and Nausicaa 1910

STATE TRETIAKOV GALLERY, MOSCOW

Valentin Serov - Gabriele d'Annunzio, Ida Rubinstein and Natalia Golubeva 1910–11

STATE TRETIAKOV GALLERY, MOSCOW

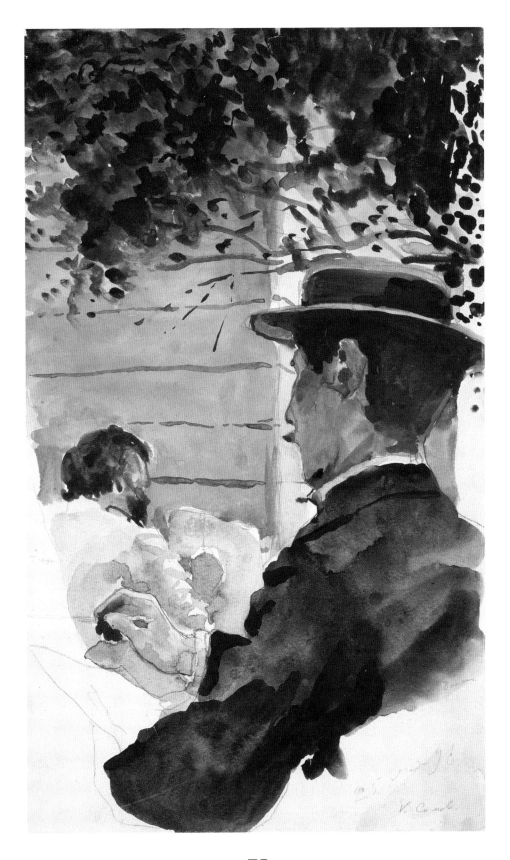

Konstantin Somov - Alexandre Benois and Léon Bakst 1896

STATE TRETIAKOV GALLERY, MOSCOW

117

-79-
Konstantin Somov - Portrait of Eugene Lanceray 1907
STATE TRETIAKOV GALLERY, MOSCOW

Konstantin Somov - Portrait of Mikhail Kuzmin 1909
STATE TRETIAKOV GALLERY, MOSCOW

119

Konstantin Somov - Portrait of Mstislav Dobuzhinsky 1910

STATE TRETIAKOV GALLERY, MOSCOW

‹83›
Konstantin Somov - Harlequin and Lady 1912

STATE TRETIAKOV GALLERY, MOSCOW

‹84›
Mikhail Vrubel - Tamara and the Demon 1890–91
STATE TRETIAKOV GALLERY, MOSCOW

◄85►
Mikhail Vrubel - Portrait of N. I. Zabela-Vrubel 1904
STATE TRETIAKOV GALLERY, MOSCOW

124

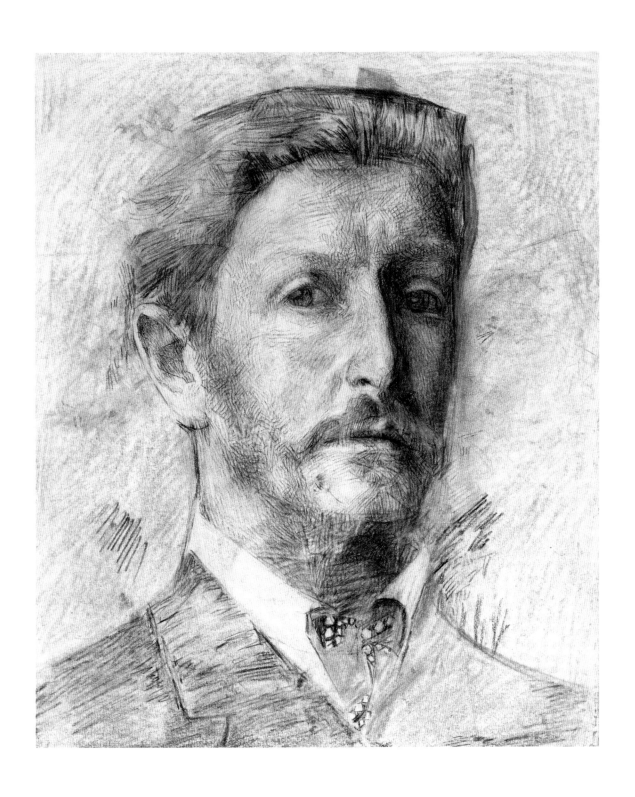

◄86►
Mikhail Vrubel - Self-portrait 1904—05
STATE TRETIAKOV GALLERY, MOSCOW

125

WORKS ON PAPER II
COSTUME AND SET DESIGNS

The world of the theatre was an extremely important source of inspiration for all the *Mir Iskusstva* artists. They began by using theatrical imagery in their paintings and graphic work to help shape their vision of an artificial world of pure beauty. Later, when they themselves were given the opportunity to produce theatrical designs, they used the stage as a laboratory in which to explore their ideas about the merging of the arts. This Petersburg variant of the *Gesamtkunstwerk* culminated in the Ballets Russes, which Diaghilev first presented in Paris in 1909.

Alexander Golovin was the first artist belonging to the group to work on a large scale for the theatre. In 1908, he produced the designs for a production of Bizet's *Carmen* at the Mariinsky Theatre (cat. 130–37). Diaghilev then approached him in 1910 to work on his presentation of Stravinsky's *L'Oiseau de feu* ballet. The set design which Golovin produced on that occasion was a triumph of Petersburg aestheticism that thrilled audiences in Paris (cat. 138).

Diaghilev also entrusted some of the costume designs for the same ballet to Léon Bakst (cat. 94), who had recently enjoyed immense success with his designs for *Cléopâtre* (1909; cat. 88) and

Schéhérazade (1910; cat. 89–93). Bakst belonged to Diaghilev's inner circle and was to become the Ballets Russes' most important designer prior to the First World War. He was unsurpassed in his ability to convey the atmosphere of exotic opulence and sensual eroticism that brought the Ballets Russes such success. Bakst helped transform theatrical design into an art form in its own right, proving that stage sets and costumes could be just as much a driving force behind a ballet or opera production as music, libretto or choreography. Diaghilev changed tack in 1914, bringing the Moscow avant-garde artists Natalia Gontcharova and Mikhail Larionov from Russia and inviting Pablo Picasso to work for him. Placing dancers and singers in a world of simplified, 'primitive' forms and gaudy, clashing colours, Gontcharova's explosive designs for *Le Coq d'or* (1914; cat. 143–47) gave a new impetus to the Ballets Russes. Her partner, Mikhail Larionov, followed suit with *Soleil de nuit* (1915; cat. 172–74) and *Les Contes russes* (1917; cat. 178, 181–82). And a few years later, Picasso completed this theatrical revolution by bringing Cubist aesthetics to the stage in ballets like *Parade* (1917; cat. 186) and *Le Tricorne* (1919; cat. 187–96).

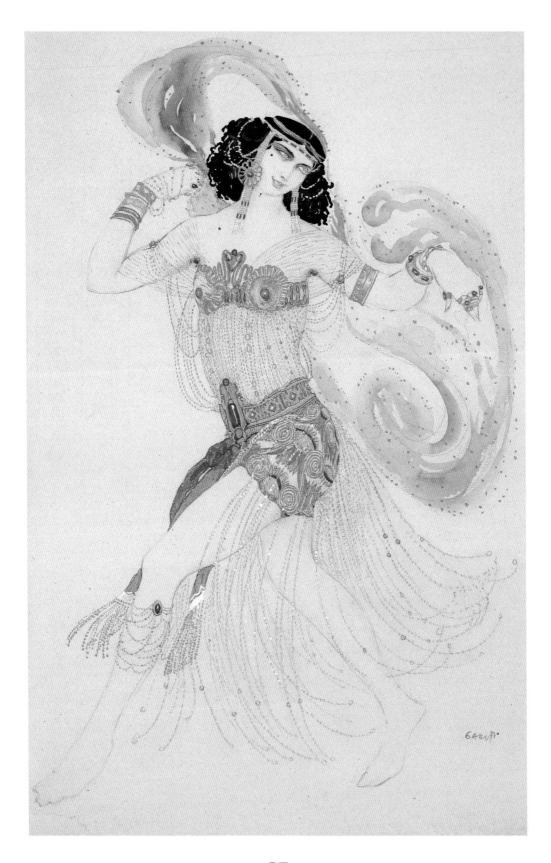

Léon Bakst - Costume design for Salomé In: Salomé, 1908

STATE TRETIAKOV GALLERY, MOSCOW

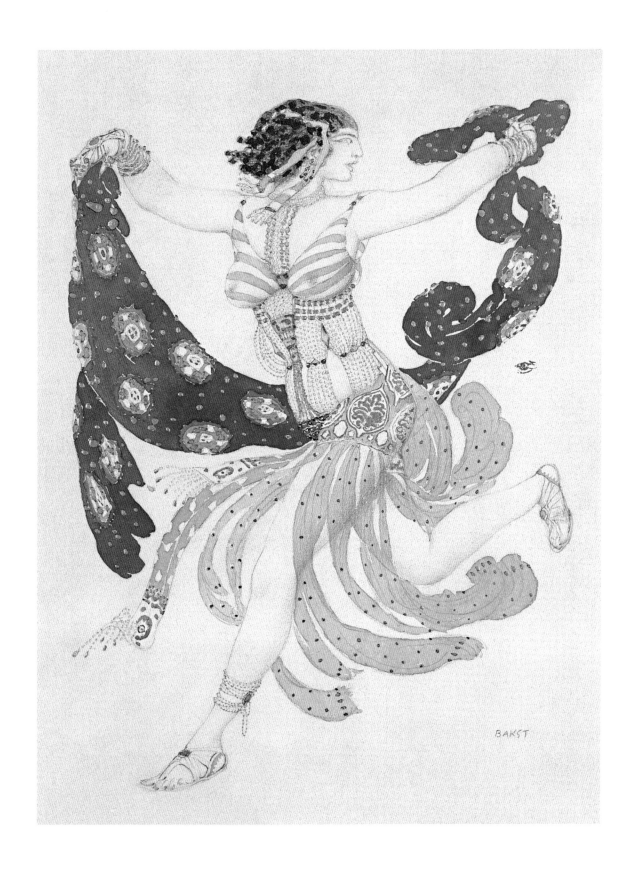

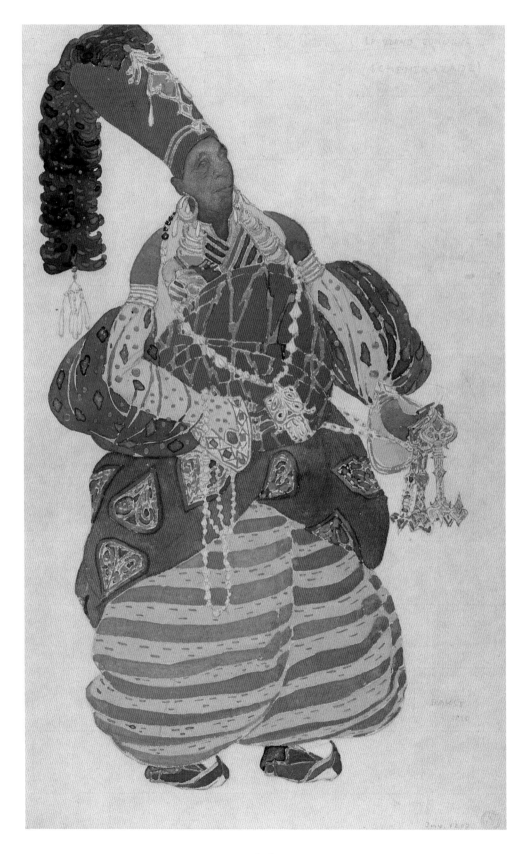

→89←
Léon Bakst - Costume design for a Chief Eunuch In: Schéhérazade, 1910
MUSÉE D'ART MODERNE ET CONTEMPORAIN DE STRASBOURG

130

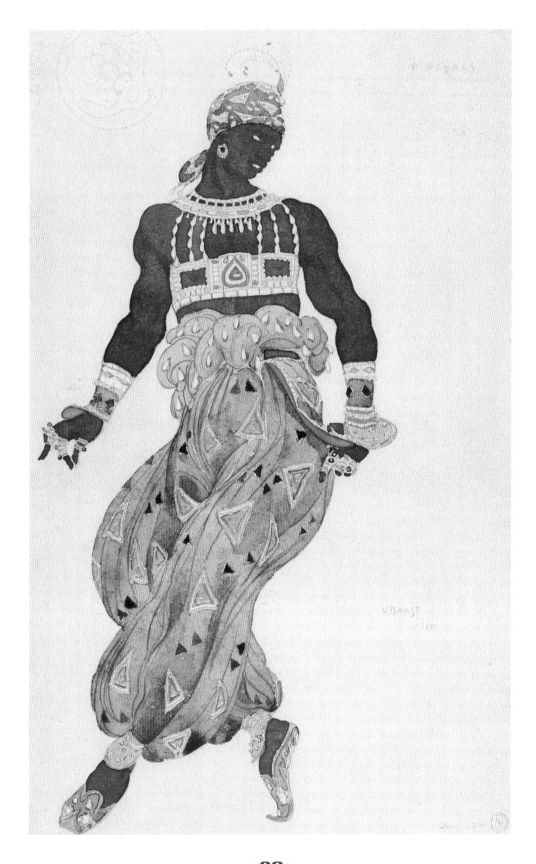

Léon Bakst - Costume design for Golden Negro In: Schéhérazade, 1910

MUSÉE D'ART MODERNE ET CONTEMPORAIN DE STRASBOURG

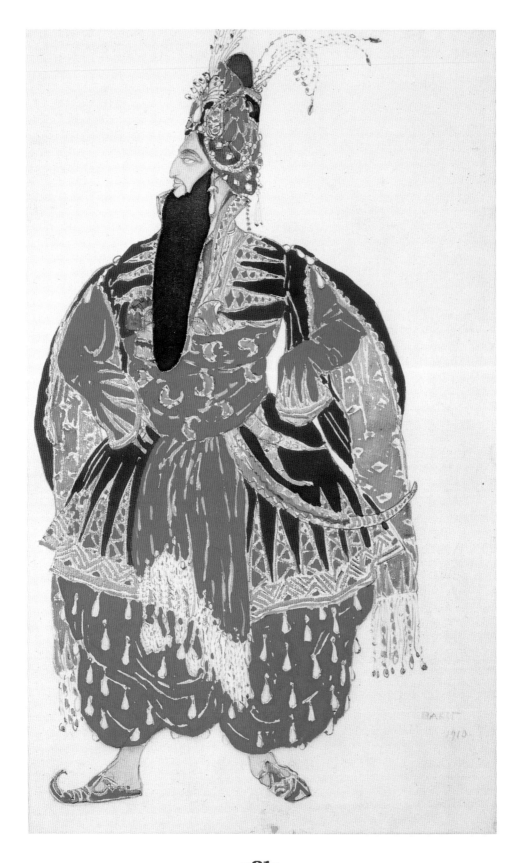

Léon Bakst - Costume design for Alexis Bulgakov as Schahriar In: Schéhérazade, 1910

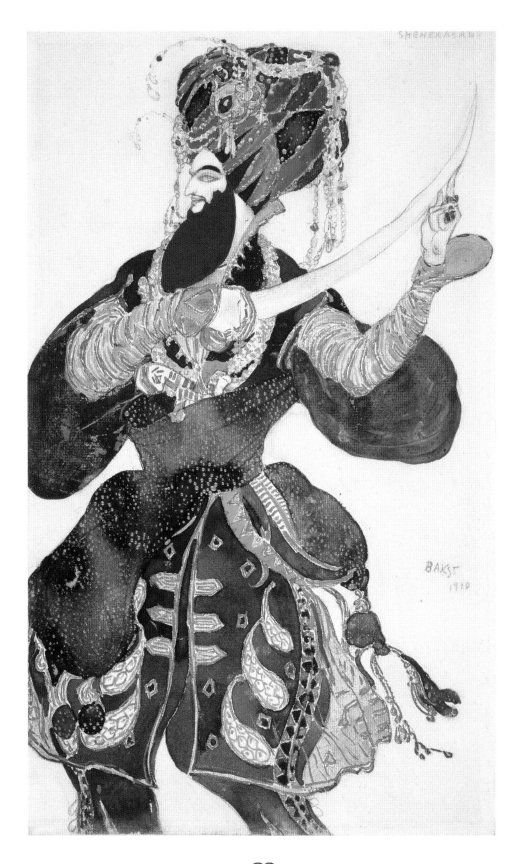

Léon Bakst - Costume design for Shah Zeman In: Schéhérazade, 1910

NATIONAL GALLERY OF AUSTRALIA, CANBERRA

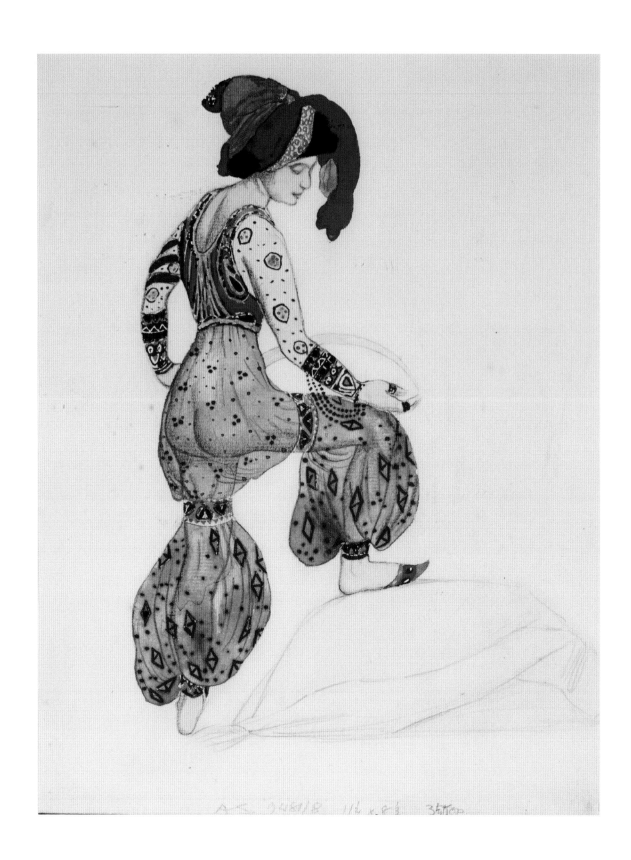

Léon Bakst - Costume design for the Blue Sultana In: Schéhérazade, 1910

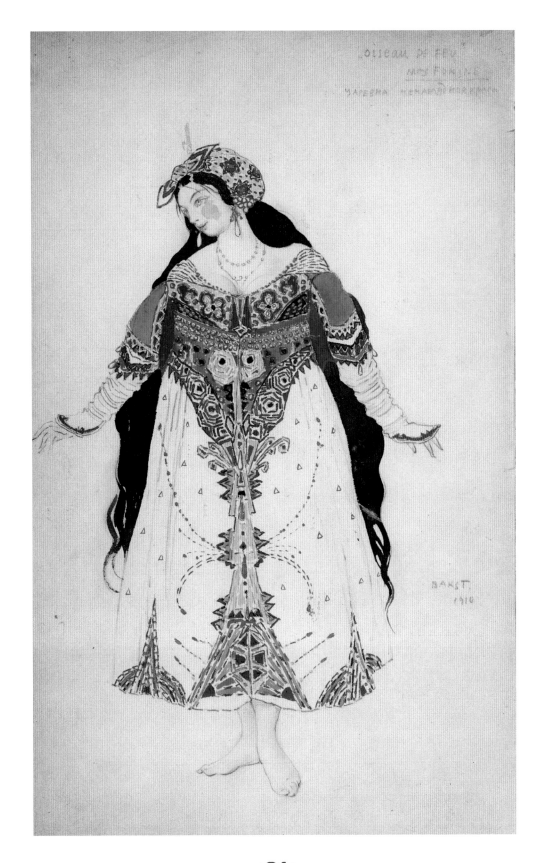

Léon Bakst - Costume design for the Tsarevna In: *L'Oiseau de feu*, 1910
STATE MUSEUM FOR THEATRE AND MUSIC, ST PETERSBURG

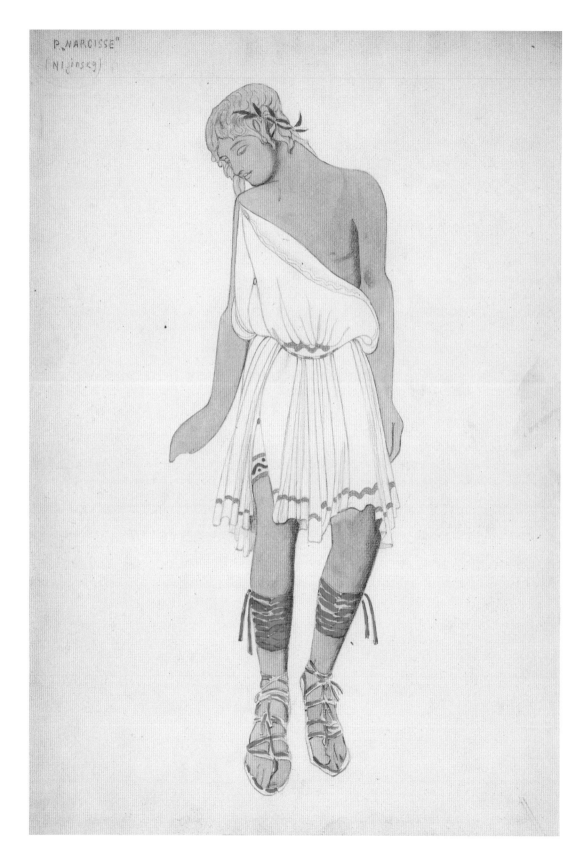

Léon Bakst - Costume design for Nijinsky as Narcissus In: Narcisse, 1911

STATE MUSEUM FOR THEATRE AND MUSIC, ST PETERSBURG

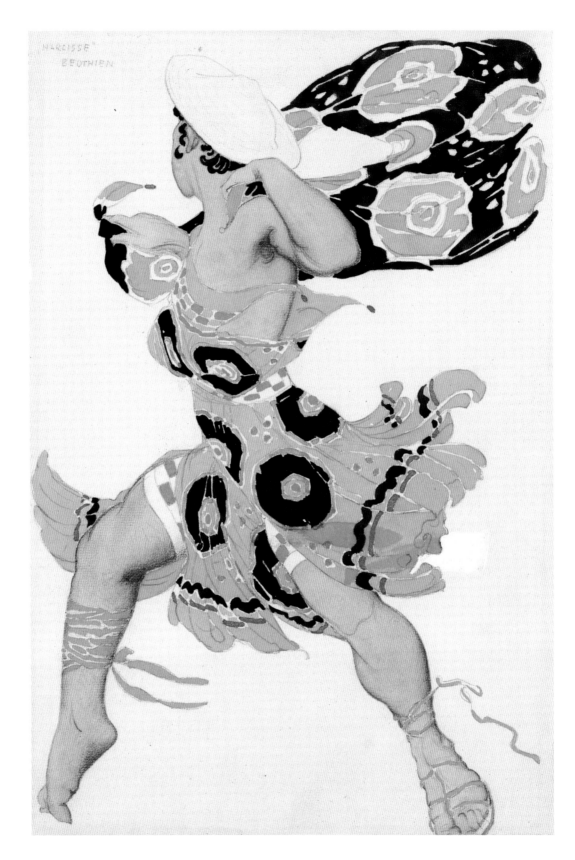

Léon Bakst - Costume design for a Boeotian Man In: Narcisse, 1911

STATE MUSEUM FOR THEATRE AND MUSIC, ST PETERSBURG

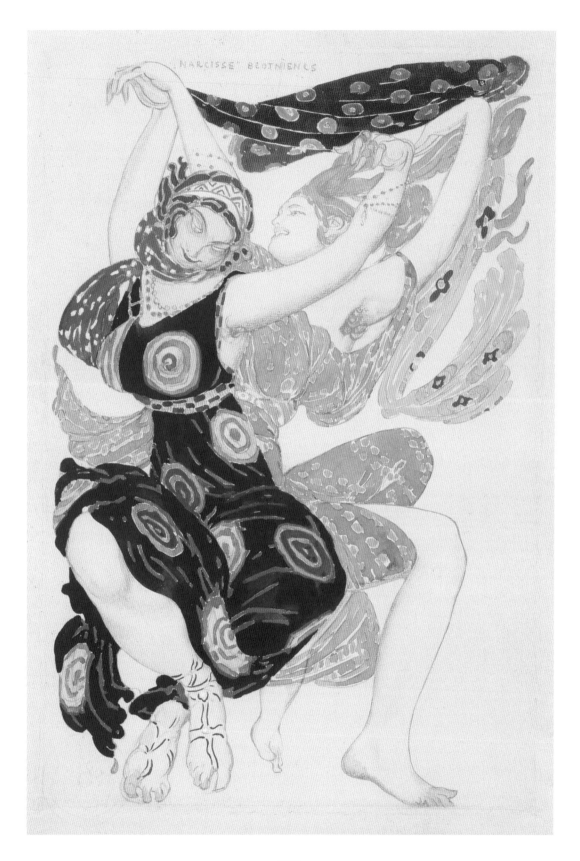

◄97►
Léon Bakst - Costume design for two Boeotian Women In: Narcisse, 1911
STATE MUSEUM FOR THEATRE AND MUSIC, ST PETERSBURG

138

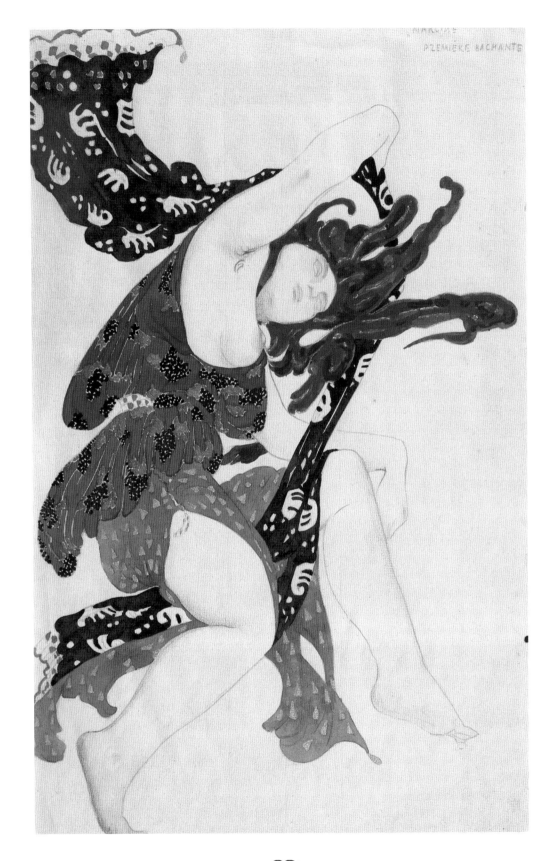

Léon Bakst - Costume design for the First Bacchante In: Narcisse, 1911

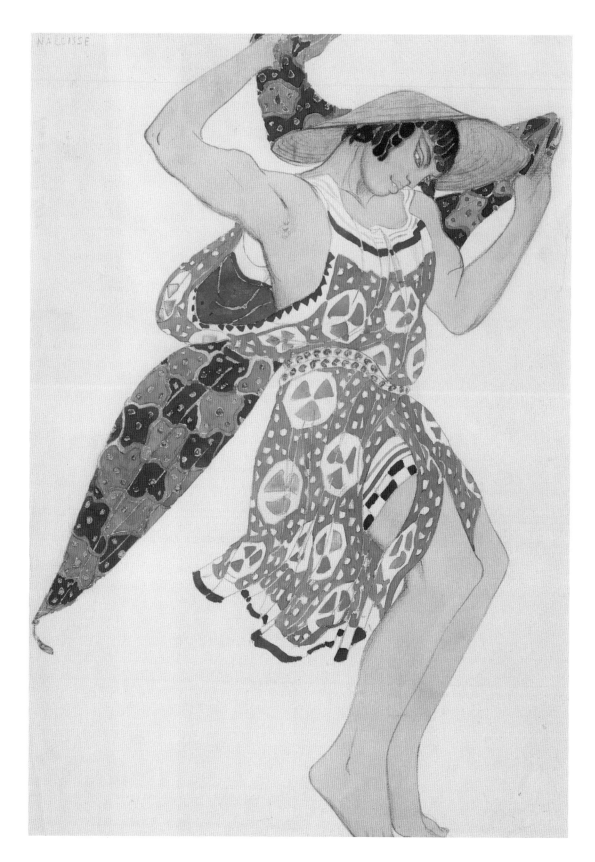

Léon Bakst - Costume design for a Boeotian Man In: Narcisse, 1911

STATE MUSEUM FOR THEATRE AND MUSIC, ST PETERSBURG

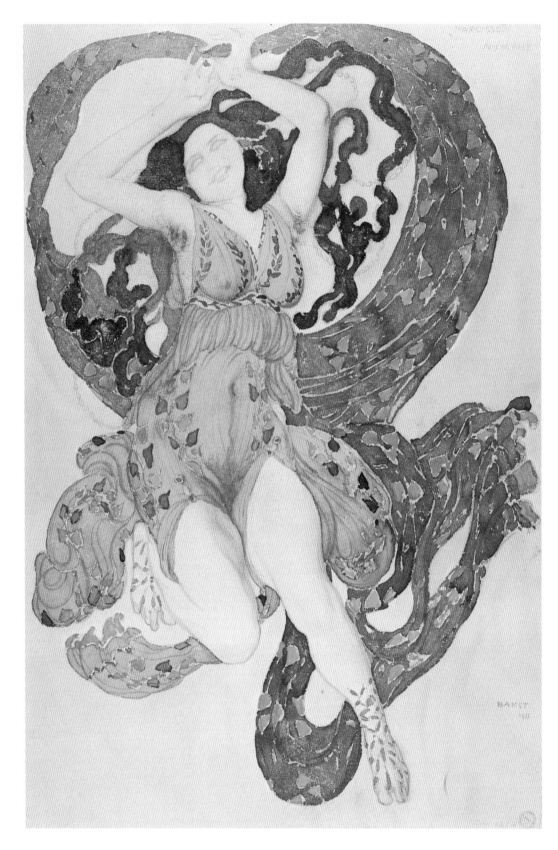

Léon Bakst - Costume design for a Nymph In: Narcisse, 1911
MUSÉE D'ART MODERNE ET CONTEMPORAIN DE STRASBOURG

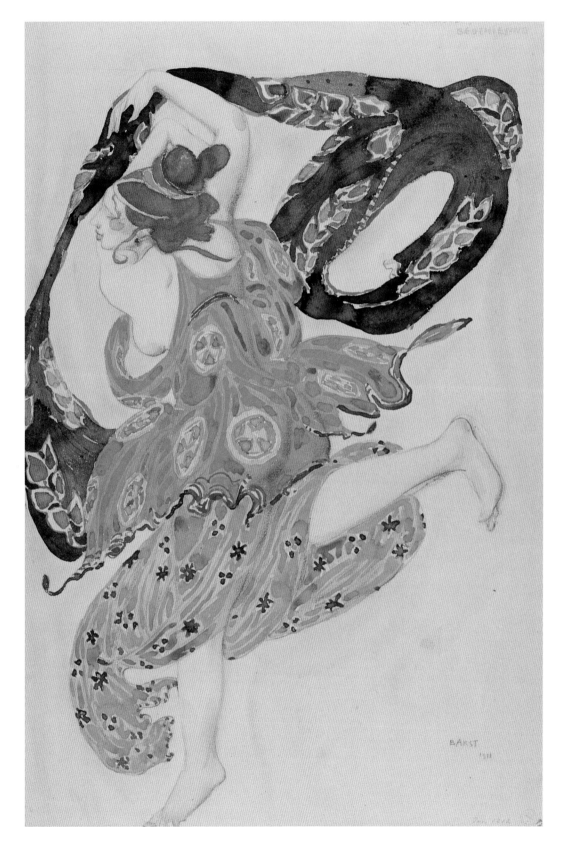

Léon Bakst - Costume design for a Boeotian Woman In: Narcisse, 1911

MUSÉE D'ART MODERNE ET CONTEMPORAIN DE STRASBOURG

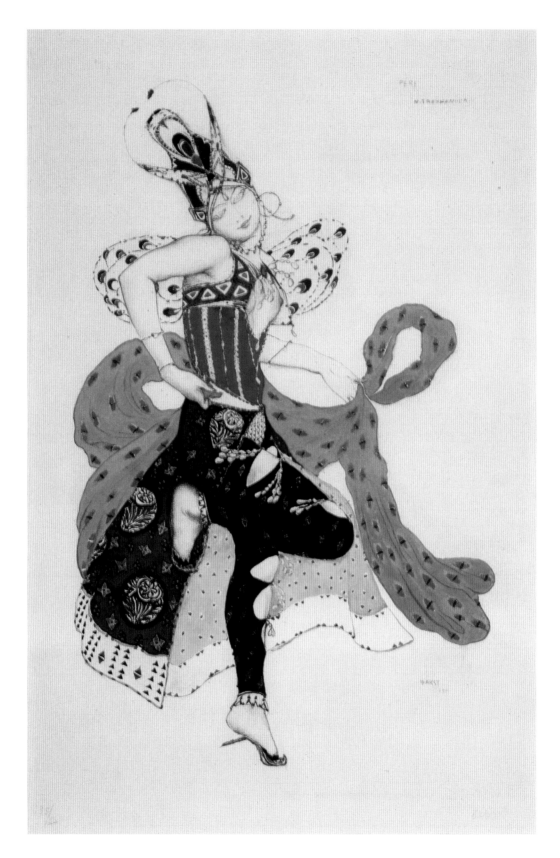

◄102►
Léon Bakst - Costume design for the Peri In: La Péri, 1911

Léon Bakst - Costume design for a Bayadere with a peacock 1911. In: Le Dieu bleu, 1912

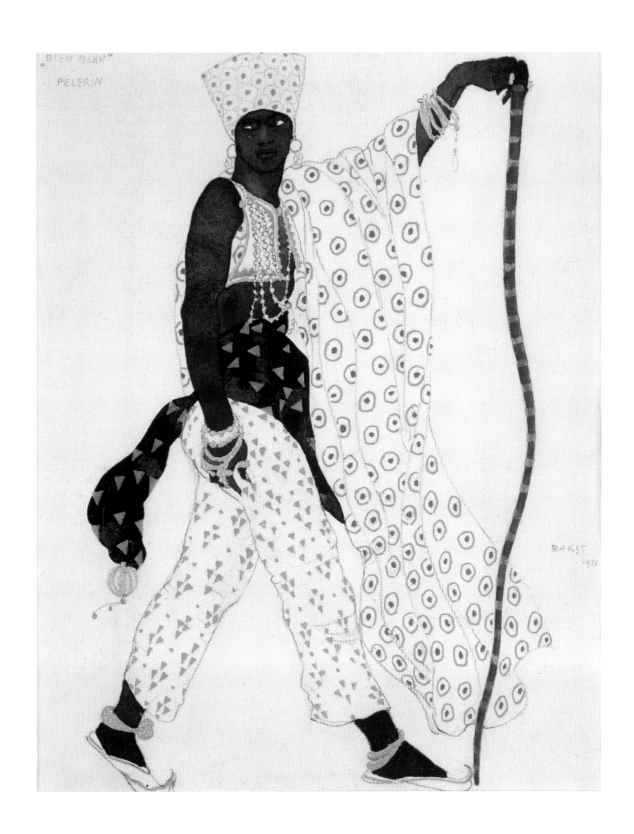

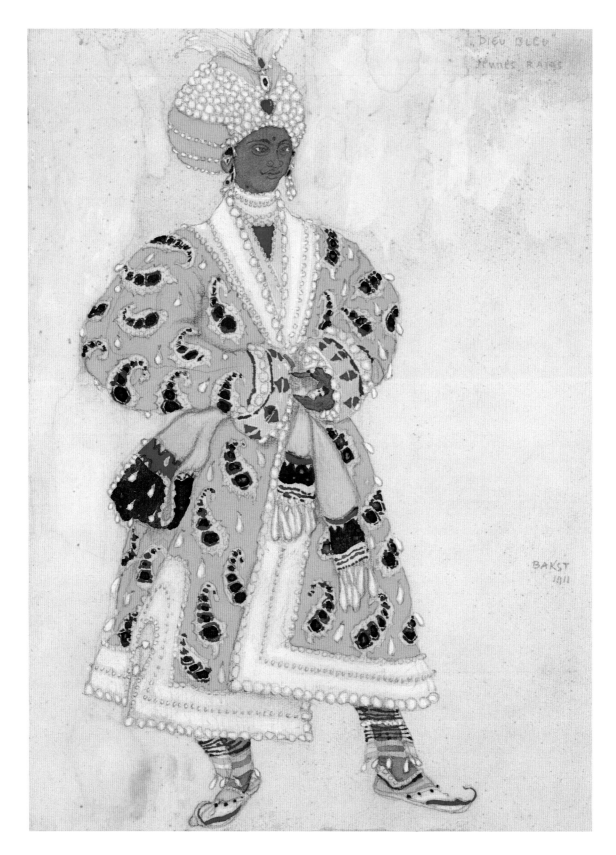

Léon Bakst - Costume design for the Young Rajah 1911. In: Le Dieu bleu, 1912

→106←
Léon Bakst - Set design for Thamar 1912
MUSÉE DES ARTS DÉCORATIFS, PARIS

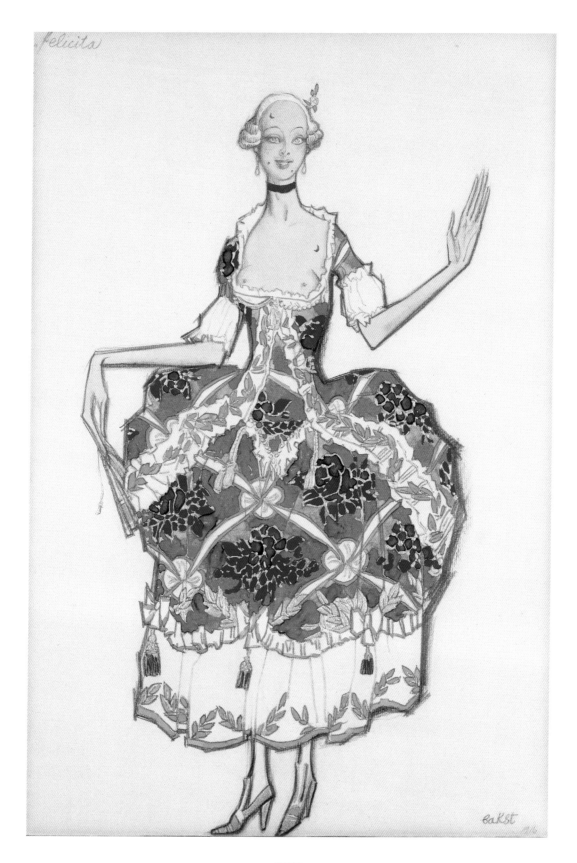

felicita

◂112▸
Léon Bakst - Costume design for Felicita In: Les Femmes de bonne humeur, 1917
VICTORIA & ALBERT MUSEUM / THEATRE MUSEUM, LONDON

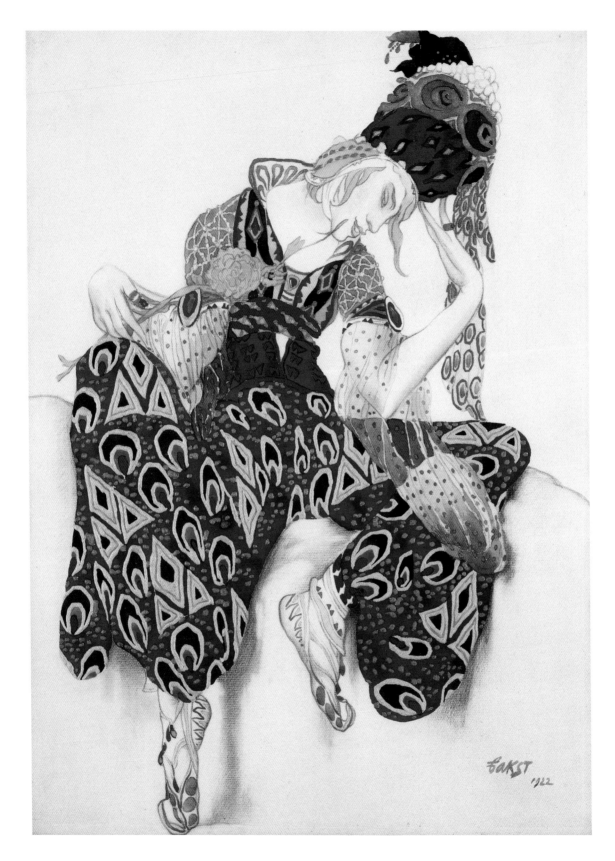

→**113**←
Léon Bakst - Costume design for Vaslav Nijinsky 1922. In: La Péri, 1911
THE METROPOLITAN MUSEUM OF ART, NEW YORK

154

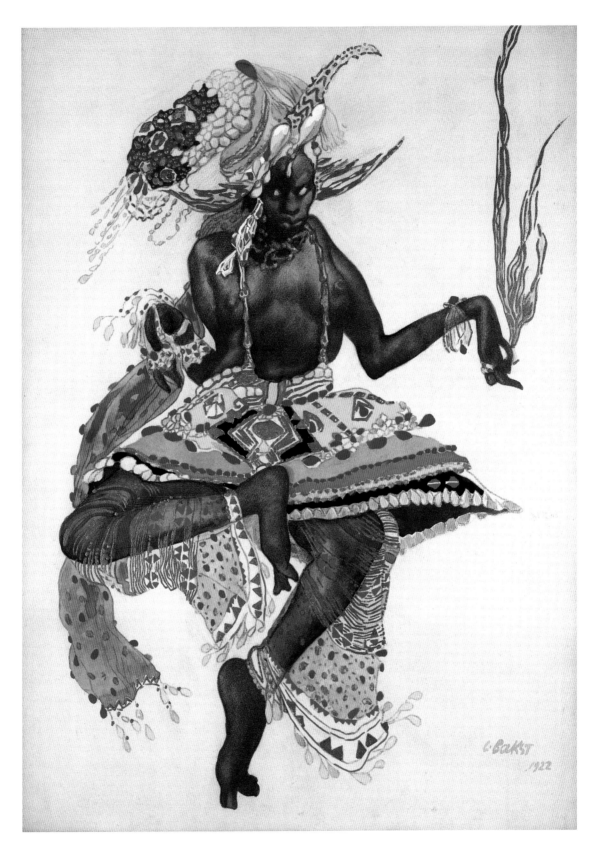

Léon Bakst - Costume design for a Temple Dancer 1922. In: Le Dieu bleu, 1912
THE MCNAY ART MUSEUM, SAN ANTONIO

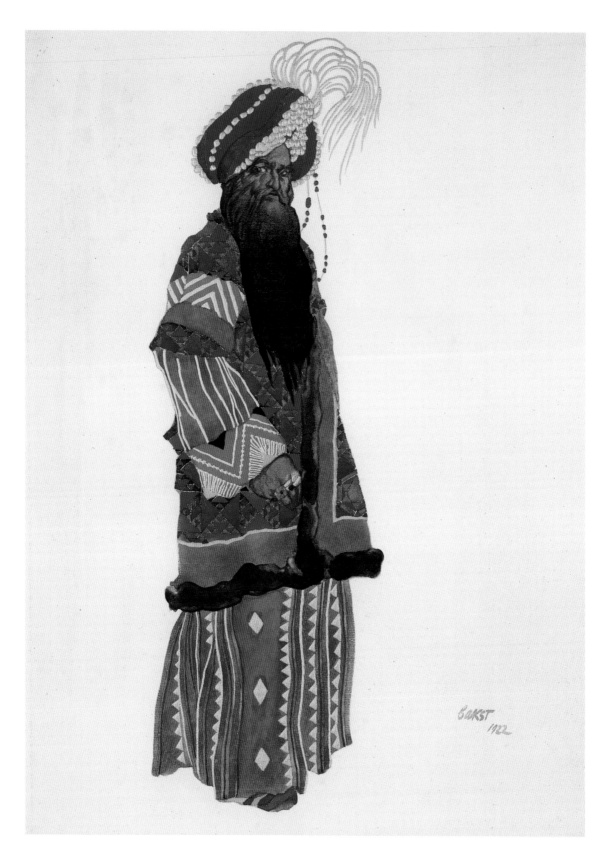

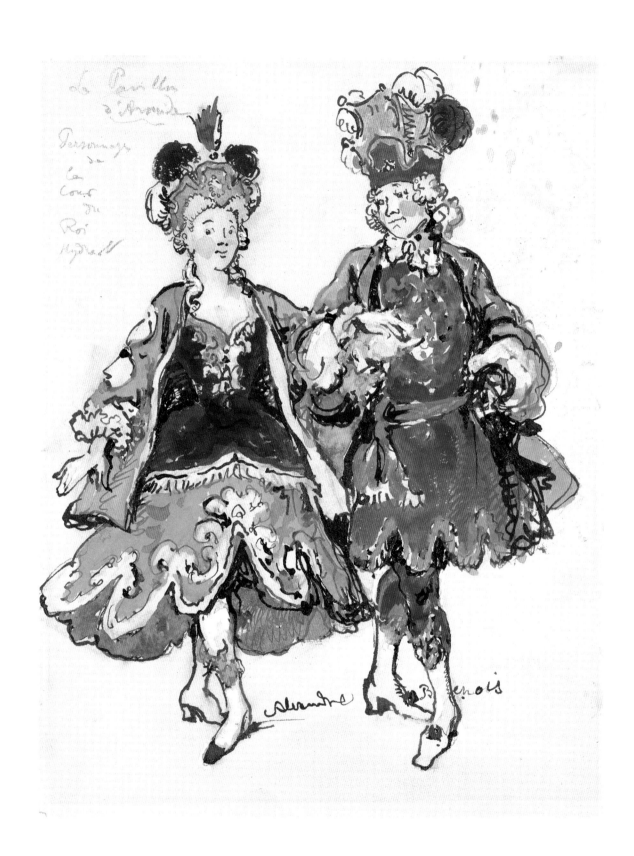

Alexandre Benois - Costume design for two Courtiers In: Le Pavillon d'Armide, 1907

VICTORIA & ALBERT MUSEUM / THEATRE MUSEUM, LONDON

Alexandre Benois - Costume design for a Devil In: Petrouchka, 1911
NATIONAL GALLERY OF AUSTRALIA, CANBERRA

Alexandre Benois - Costume design for the Ballerina In: Petrouchka, 1911
VICTORIA & ALBERT MUSEUM / THEATRE MUSEUM, LONDON

Alexandre Benois - Costume design for the Magician 1936. In: Petrouchka, 1911

VICTORIA & ALBERT MUSEUM / THEATRE MUSEUM, LONDON

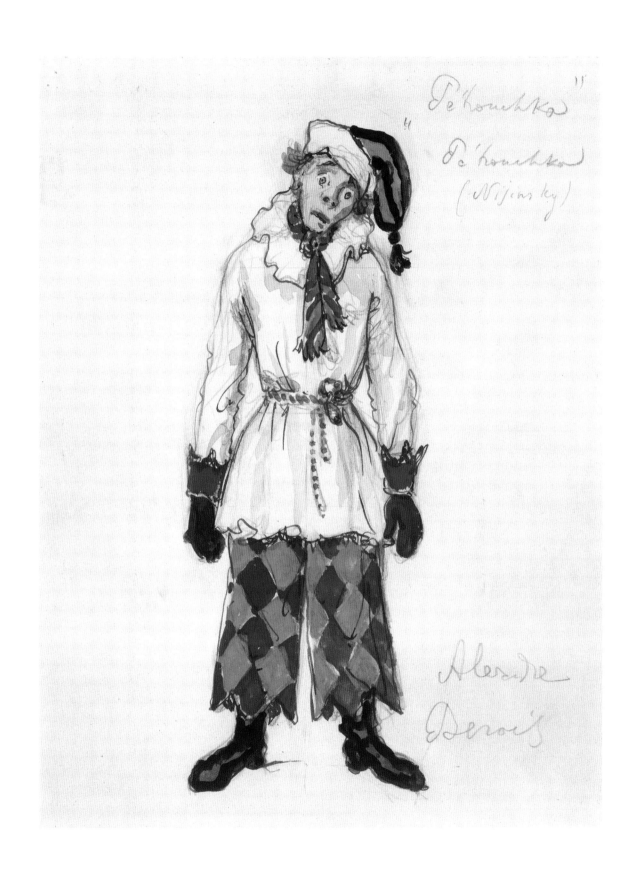

Alexandre Benois - Costume design for Petrushka In: Petrouchka, 1911
VICTORIA & ALBERT MUSEUM / THEATRE MUSEUM, LONDON

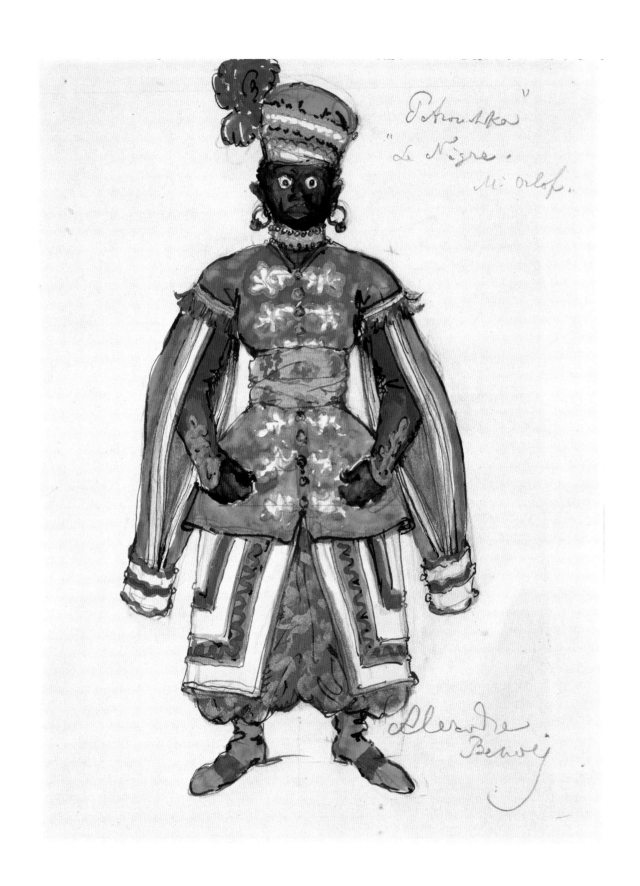

Alexandre Benois - Costume design for the Negro In: Petrouchka, 1911

VICTORIA & ALBERT MUSEUM / THEATRE MUSEUM, LONDON

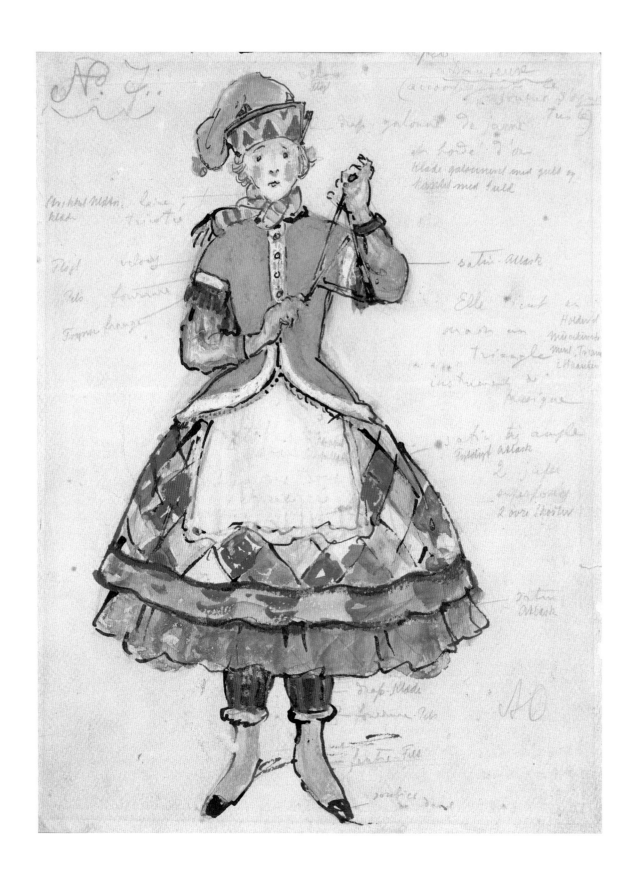

Alexandre Benois - Costume design for the Street Dancer In: Petrouchka, 1911

Alexandre Benois - Costume design for the Nurse Maid In: Petrouchka, 1911

VICTORIA & ALBERT MUSEUM / THEATRE MUSEUM, LONDON

Alexandre Benois - Costume design for a Woman and Child In: Petrouchka, 1911

Alexandre Benois - Costume design for a Chinese Guard In: Le Rossignol, 1914

◄127►
Giorgio De Chirico - Costume design for Anton Dolin
In: Le Bal, 1929

VICTORIA & ALBERT MUSEUM / THEATRE MUSEUM, LONDON

◄128►
Giorgio De Chirico - Costume design for Eugénie Lipkovska as the Woman in the Italian Entrée In: Le Bal, 1929

WADSWORTH ATHENEUM MUSEUM OF ART, HARTFORD

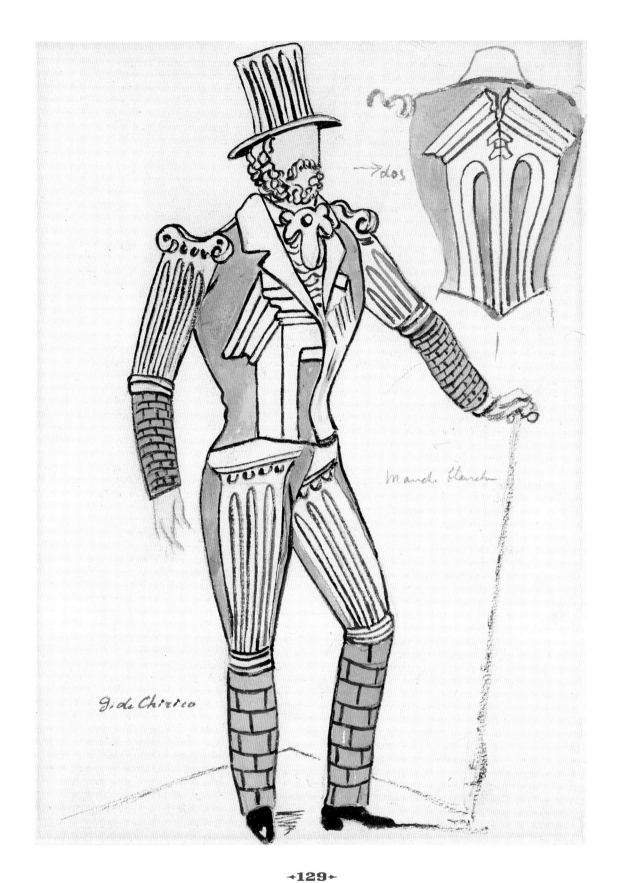

Giorgio De Chirico - Costume design for a Male Guest In: Le Bal, 1929
WADSWORTH ATHENEUM MUSEUM OF ART, HARTFORD

Alexander Golovin - Set design for 'Near the Bullring' in Carmen 1908
STATE CENTRAL THEATRE MUSEUM A.A. BAKHRUSHIN, MOSCOW

◄132►
**Alexander Golovin - Costume design for Youths
surrounding Carmen, Act 1** In: Carmen, 1908

STATE CENTRAL THEATRE MUSEUM A.A. BAKHRUSHIN, MOSCOW

◄133►
**Alexander Golovin - Costume design for
Peasant Women from Murcia** In: Carmen, 1908

STATE CENTRAL THEATRE MUSEUM A.A. BAKHRUSHIN, MOSCOW

172

◄134►
Alexander Golovin - Costume design for Mercedes
In: Carmen, 1908
STATE CENTRAL THEATRE MUSEUM A.A. BAKHRUSHIN, MOSCOW

◄135►
Alexander Golovin - Costume design for an Espada
In: Carmen, 1908
STATE CENTRAL THEATRE MUSEUM A.A. BAKHRUSHIN, MOSCOW

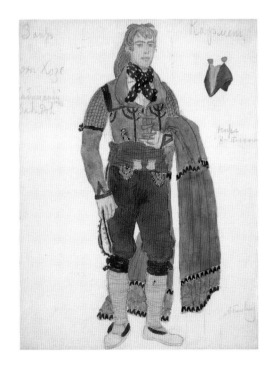

◄136►
Alexander Golovin - Costume design for José
In: Carmen, 1908
STATE CENTRAL THEATRE MUSEUM A.A. BAKHRUSHIN, MOSCOW

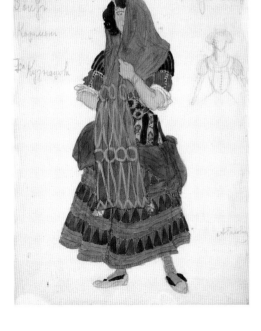

◄137►
Alexander Golovin - Costume design for Carmen
In: Carmen, 1908
STATE CENTRAL THEATRE MUSEUM A.A. BAKHRUSHIN, MOSCOW

◂138▸
Alexander Golovin - Set design for the 'Realm of Koshchey' in L'Oiseau de feu 1910

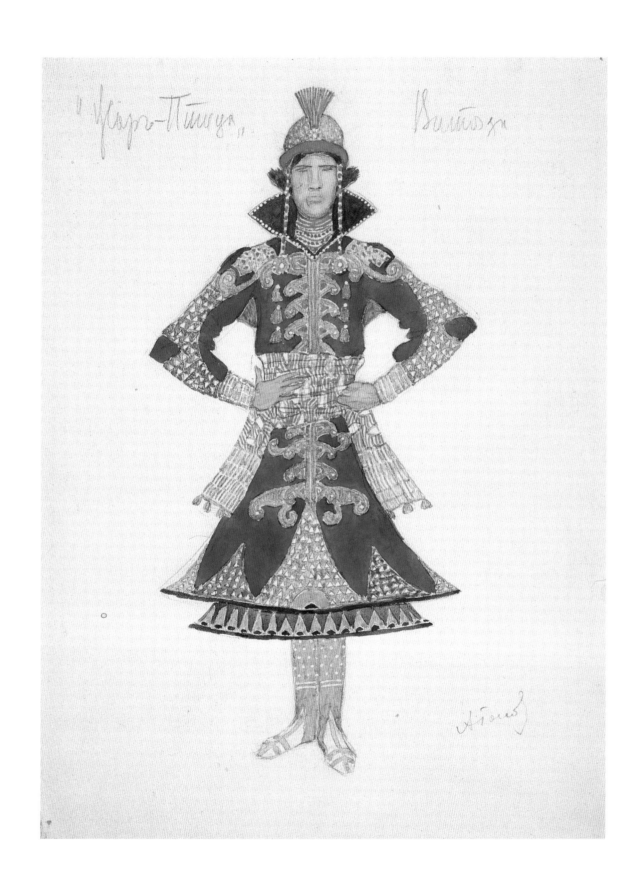

◆139◆
Alexander Golovin - Costume design for Vitiaz In: L'Oiseau de feu, 1910

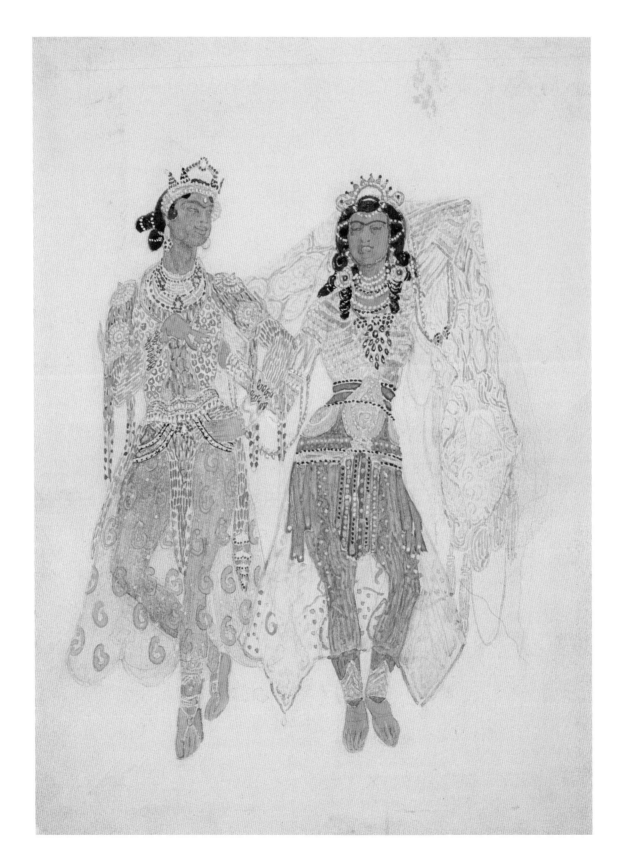

◄142►
Alexander Golovin - Costume design for two Women In: L'Oiseau de feu, 1910
STATE MUSEUM FOR THEATRE AND MUSIC, ST PETERSBURG

176

‹143›
Natalia Gontcharova - Costume design for a Peasant Woman In: Le Coq d'or, 1914
NATIONAL GALLERY OF AUSTRALIA, CANBERRA

Natalia Gontcharova - Set design for the first act of Le Coq d'or 1914

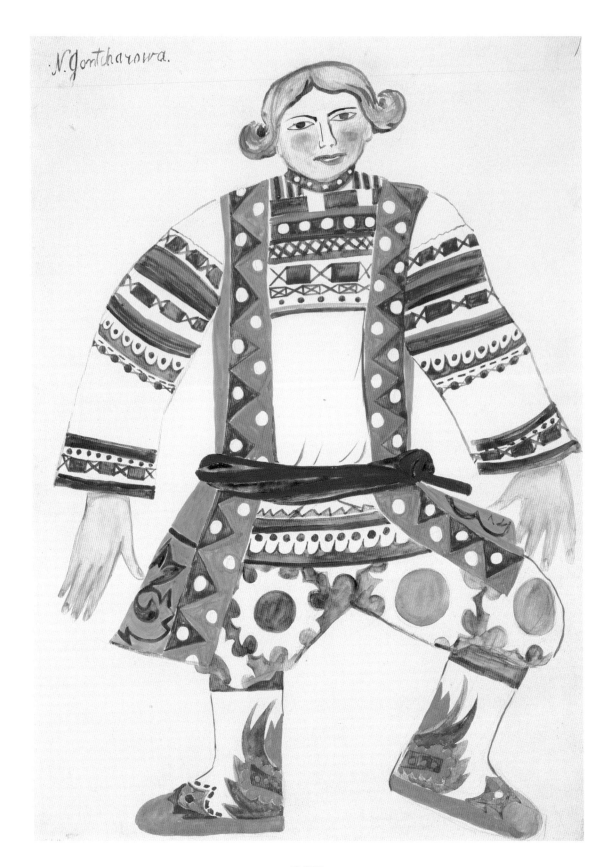

◆146◆
Natalia Gontcharova - Costume design for a Russian Peasant In: Le Coq d'or, 1914

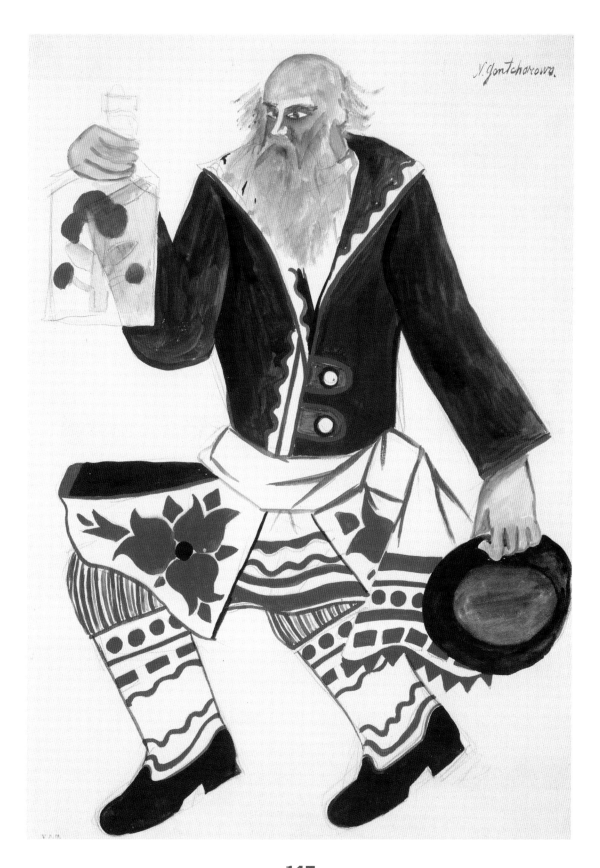

Natalia Gontcharova - Costume design for a Russian Peasant In: Le Coq d'or, 1914

VICTORIA & ALBERT MUSEUM, LONDON

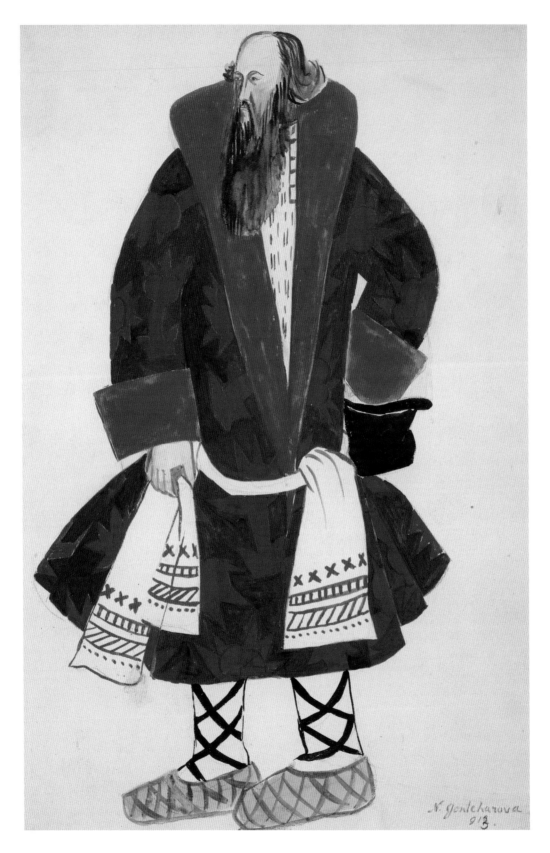

✦148✦
Natalia Gontcharova - Stolnik 1915

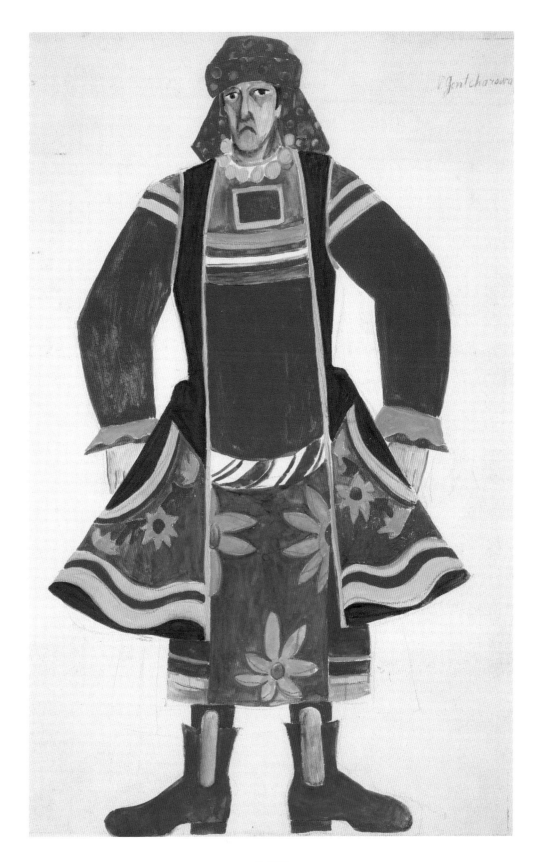

→149←
Natalia Gontcharova - Woman 1915
STATE TRETIAKOV GALLERY, MOSCOW

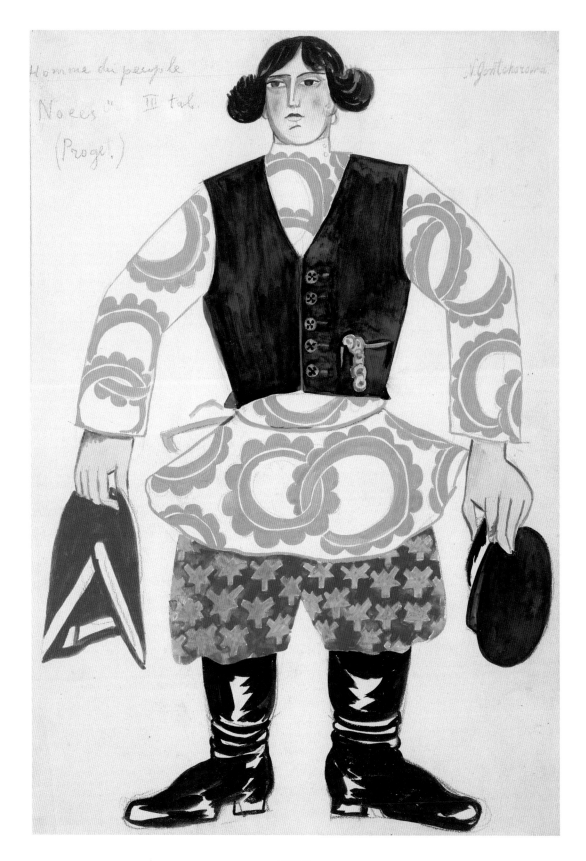

→150←
Natalia Gontcharova - Man of the people 1915
STATE TRETIAKOV GALLERY, MOSCOW

◆151◆
Natalia Gontcharova - Costume design
for a six-winged Seraph 1915/27
CENTRE GEORGES POMPIDOU, PARIS

◆152◆
Natalia Gontcharova - Costume design
for an Angel 1915/27
CENTRE GEORGES POMPIDOU, PARIS

◆153◆
Natalia Gontcharova - Costume design
for an Angel of the Annunciation 1915/27
CENTRE GEORGES POMPIDOU, PARIS

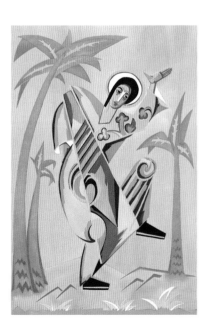

◆154◆
Natalia Gontcharova - Costume design
for St John 1915/27
CENTRE GEORGES POMPIDOU, PARIS

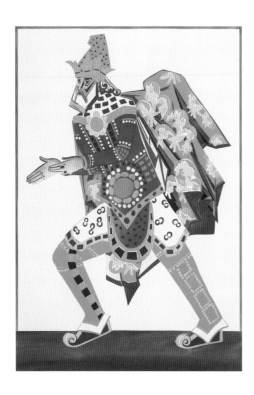

←155→
Natalia Gontcharova -
Costume design for one of the Three Kings 1915/27
CENTRE GEORGES POMPIDOU, PARIS

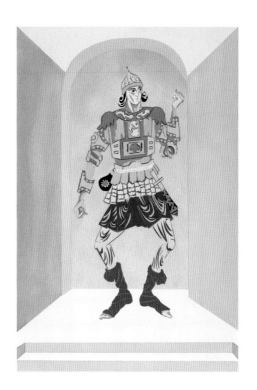

←156→
Natalia Gontcharova -
Costume design for a Soldier 1915/27
CENTRE GEORGES POMPIDOU, PARIS

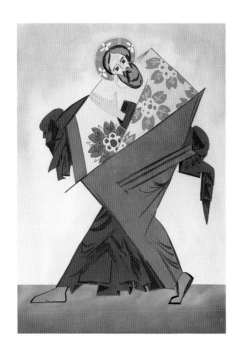

←157→
Natalia Gontcharova -
Costume design for St Andrew 1915/27
CENTRE GEORGES POMPIDOU, PARIS

←158→
Natalia Gontcharova -
Costume design for an Apostle 1915/27
CENTRE GEORGES POMPIDOU, PARIS

◄159►
Natalia Gontcharova -
Costume design for St Matthew 1915/27
CENTRE GEORGES POMPIDOU, PARIS

◄160►
Natalia Gontcharova -
Costume design for Judas 1915/27
CENTRE GEORGES POMPIDOU, PARIS

187

◄161►
Natalia Gontcharova - Costume design for a Fish In: Sadko, 1916

Natalia Gontcharova - Costume design for a Spaniard with a scarf 1916

Natalia Gontcharova - Spanish woman with a green scarf 1916

STATE TRETIAKOV GALLERY, MOSCOW

Natalia Gontcharova - Composition with factory stacks 1916–17

◆165◆
Natalia Gontcharova - The play of Igor's campaign *c.* 1923
CENTRE GEORGES POMPIDOU, PARIS

Natalia Gontcharova - Set design for The Firebird 1926
VICTORIA & ALBERT MUSEUM, LONDON

Natalia Gontcharova - Set design for the final scene of The Firebird 1926

◄168►
Natalia Gontcharova - Set design for the finale of The Firebird 1926
COLLECTION NIKITA AND NINA LOBANOV-ROSTOVSKY, LONDON

195

◄**169**►
Natalia Gontcharova - Front cloth 1937
CENTRE GEORGES POMPIDOU, PARIS

196

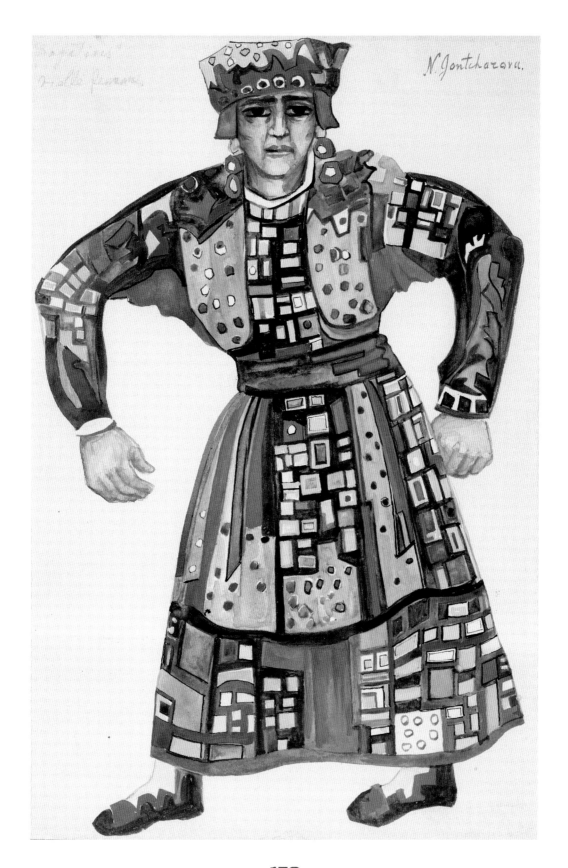

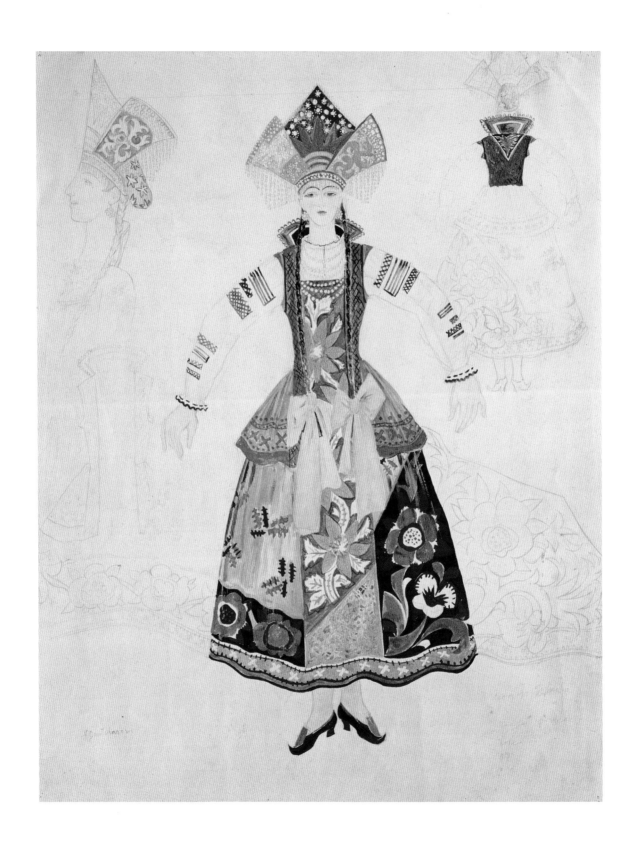

⇥171⇤

Natalia Gontcharova - Costume design for a Russian Woman, for Anna Pavlova

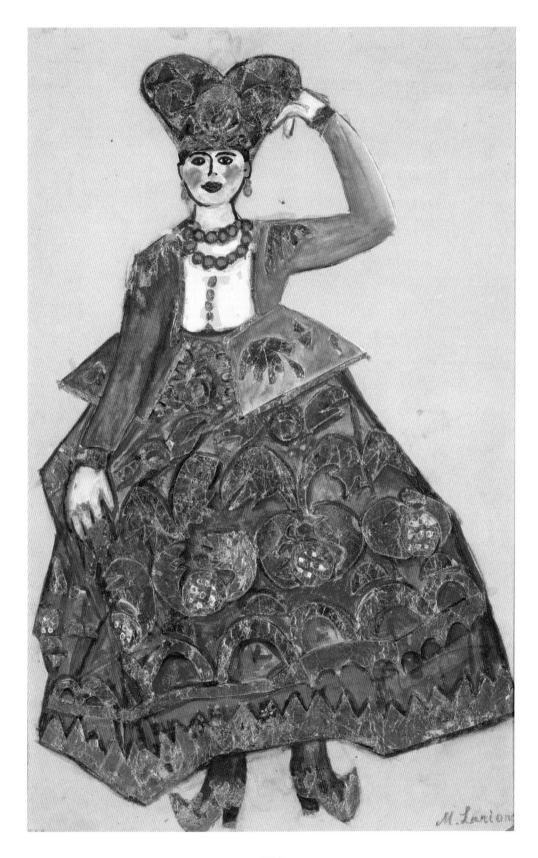

Mikhail Larionov - Costume design for a Peasant Woman In: Soleil de nuit, 1915

VICTORIA & ALBERT MUSEUM, LONDON

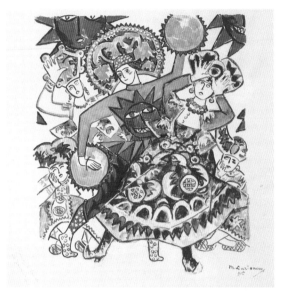

◄173►
Mikhail Larionov - Set design for Soleil de nuit 1915
VICTORIA & ALBERT MUSEUM / THEATRE MUSEUM, LONDON

◄174►
Mikhail Larionov - Soleil de nuit 1915
CENTRE GEORGES POMPIDOU, PARIS

200

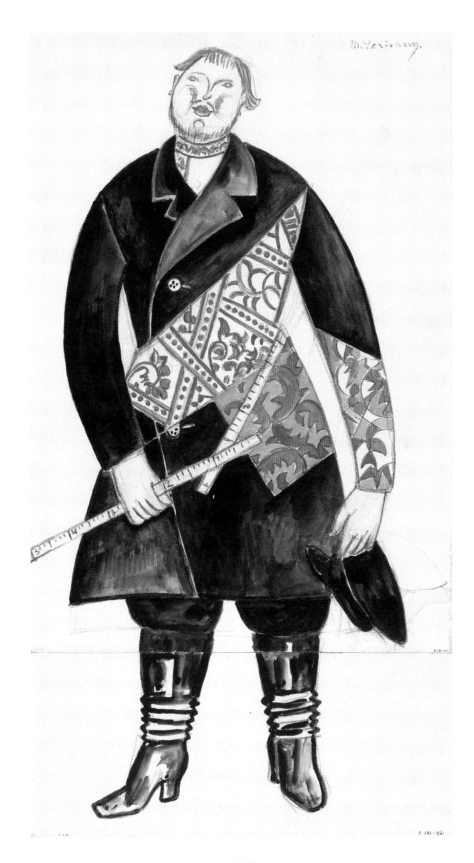

Mikhail Larionov - Costume design for the Merchant 1915. In: Chout, 1921

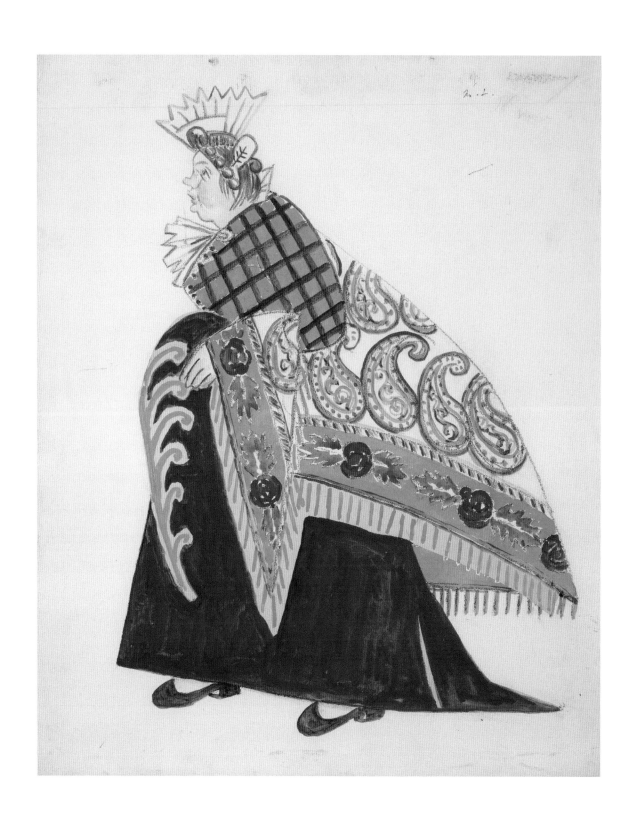

Mikhail Larionov - Costume design for a Procuress 1915. In: Chout, 1921

STATE TRETIAKOV GALLERY, MOSCOW

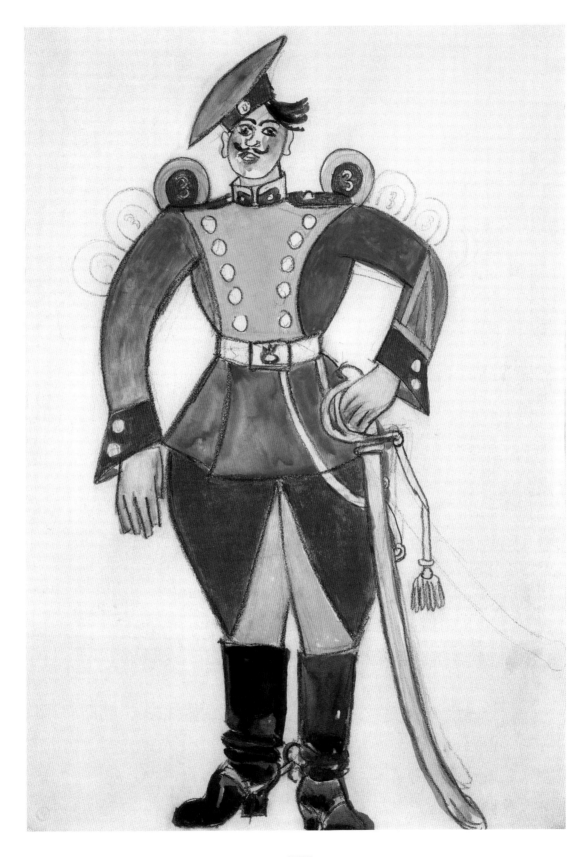

Mikhail Larionov - Costume design for the Soldier 1915. In: Chout, 1921

Mikhail Larionov - Set design for 'The Magic Pool' in Les Contes russes 1916. In: Les Contes russes, 1917

VICTORIA & ALBERT MUSEUM, LONDON

Mikhail Larionov - Costume design for a Peacock 1916
MUSÉE D'ART MODERNE ET CONTEMPORAIN DE STRASBOURG

⟨181⟩
Mikhail Larionov - Costume design for a Woman 1916–17. In: Les Contes russes, 1917

◄183►
Mikhail Larionov - Set design for the fifth act of Chout 1921
CENTRE GEORGES POMPIDOU, PARIS

◄184►
Mikhail Larionov - Costume design for the Buffoon's Wife In: Chout, 1921
THE MCNAY ART MUSEUM, SAN ANTONIO

Mikhail Larionov - Set design for Le Renard 1929
VICTORIA & ALBERT MUSEUM / THEATRE MUSEUM, LONDON

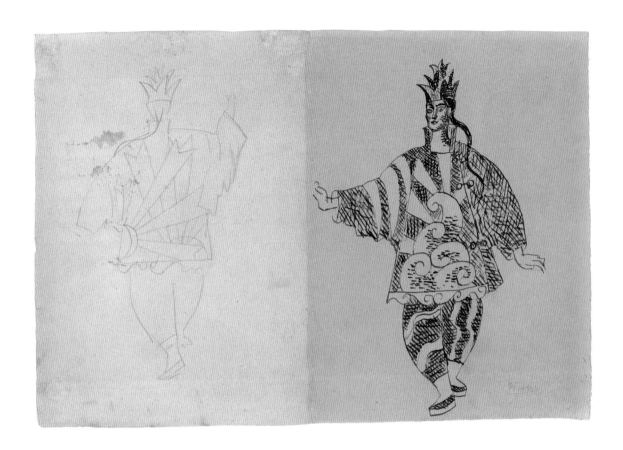

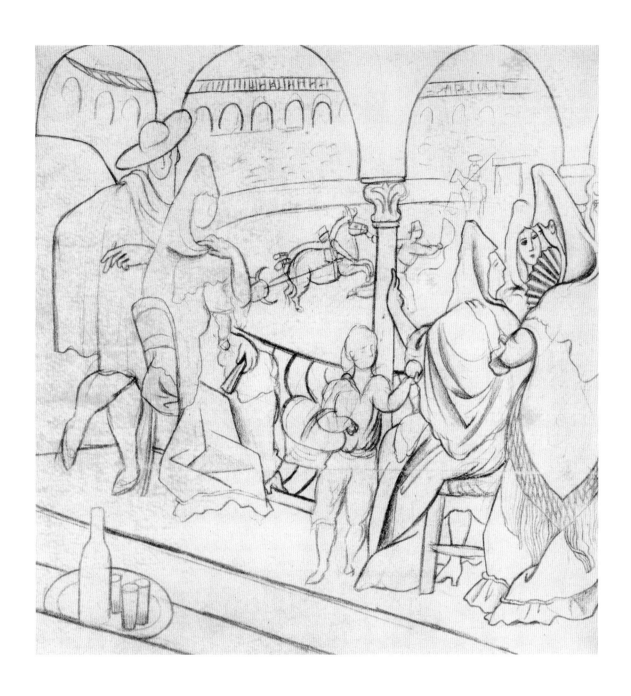

→188→
Pablo Picasso - View of a Spanish town with blue sky 1919
COLLECTION NIKITA AND NINA LOBANOV-ROSTOVSKY, LONDON

214

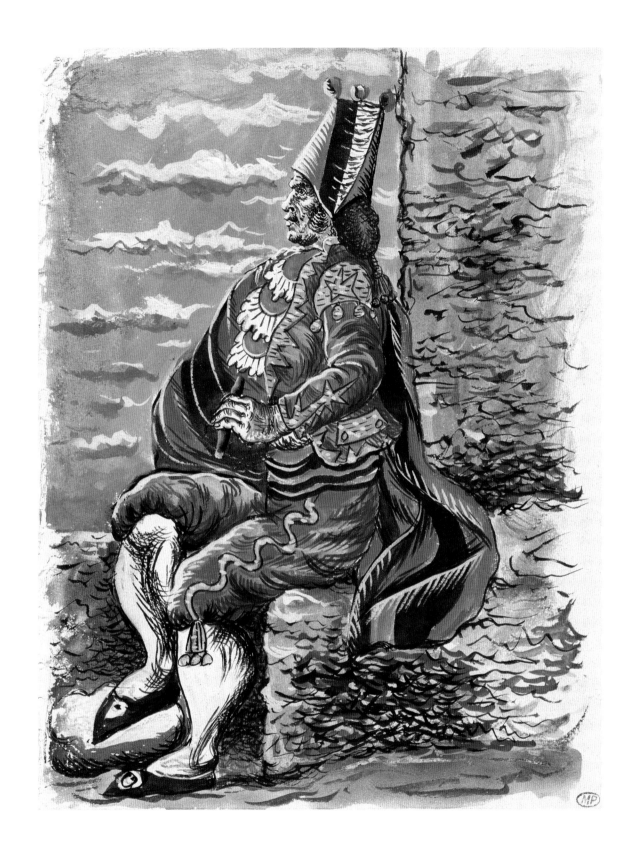

◄189►
Pablo Picasso - Costume design for the Bullfighter In: Le Tricorne, 1919

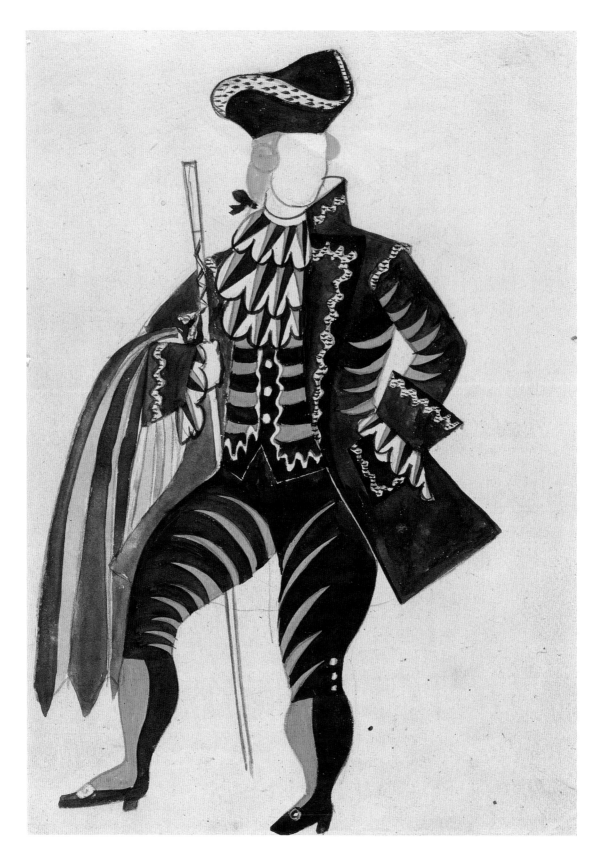

→190→
Pablo Picasso - Costume design for the Corregidor In: Le Tricorne, 1919

MUSÉE PICASSO, PARIS

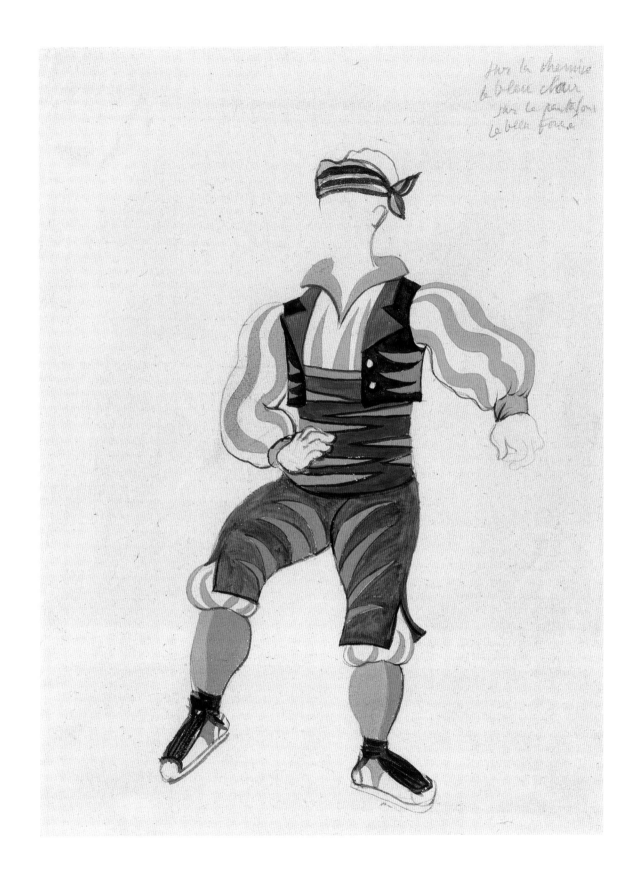

◄191►
Pablo Picasso - Costume design for a Neighbour In: Le Tricorne, 1919

MUSÉE PICASSO, PARIS

217

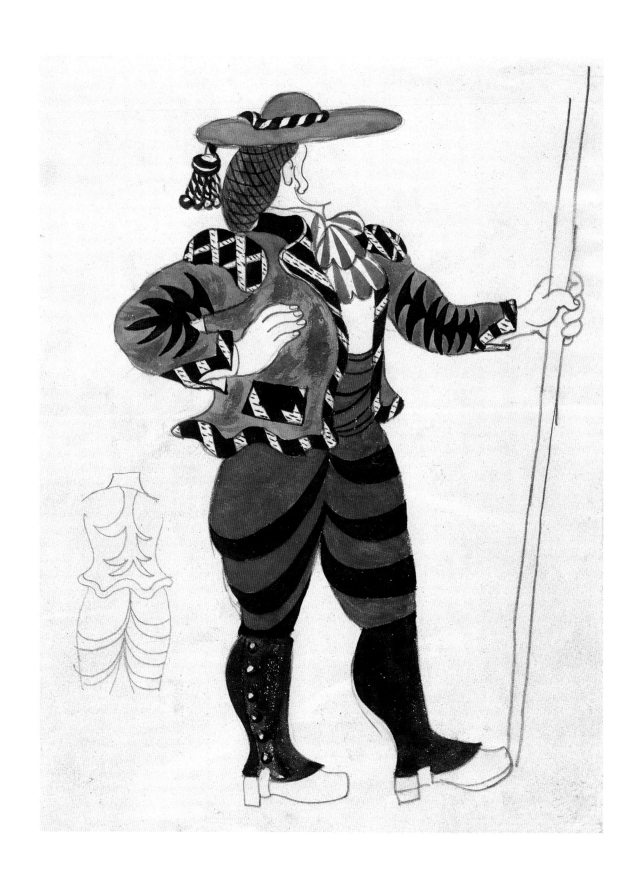

Pablo Picasso - Costume design for a Picador In: Le Tricorne, 1919

MUSÉE PICASSO, PARIS

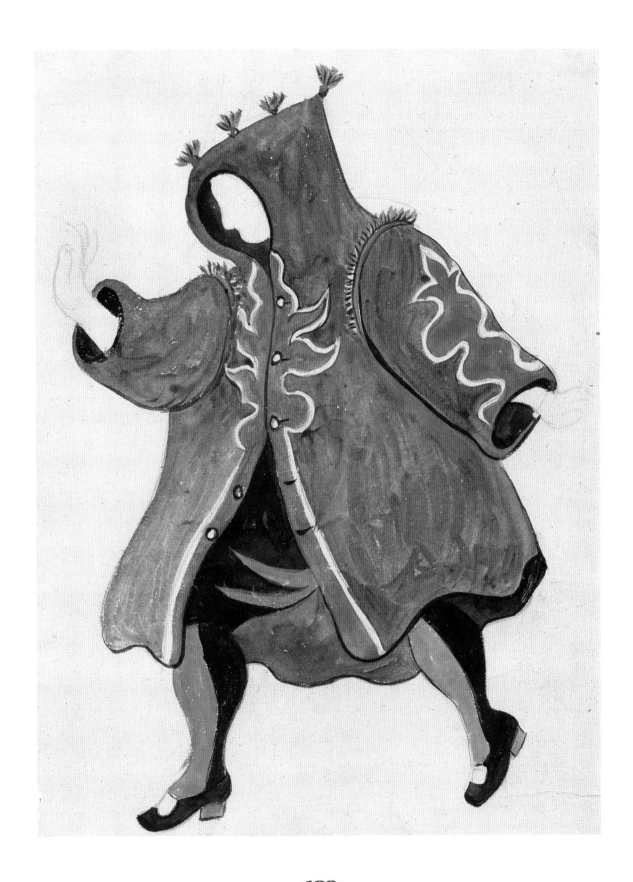

Pablo Picasso - Costume design for the Corregidor in the cloak of the Miller In: Le Tricorne, 1919

MUSÉE PICASSO, PARIS

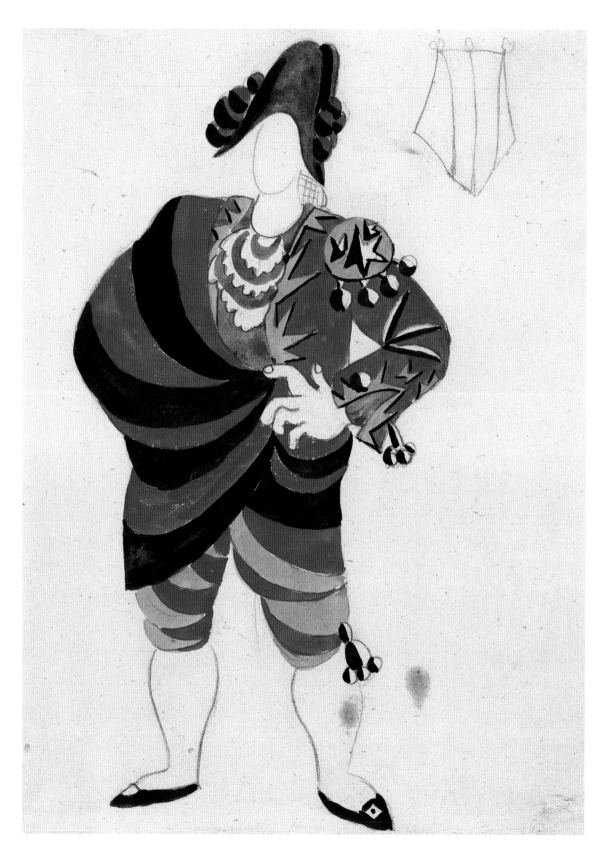

Pablo Picasso - Costume design for the Partner of the Woman of Seville In: Le Tricorne, 1919

MUSÉE PICASSO, PARIS

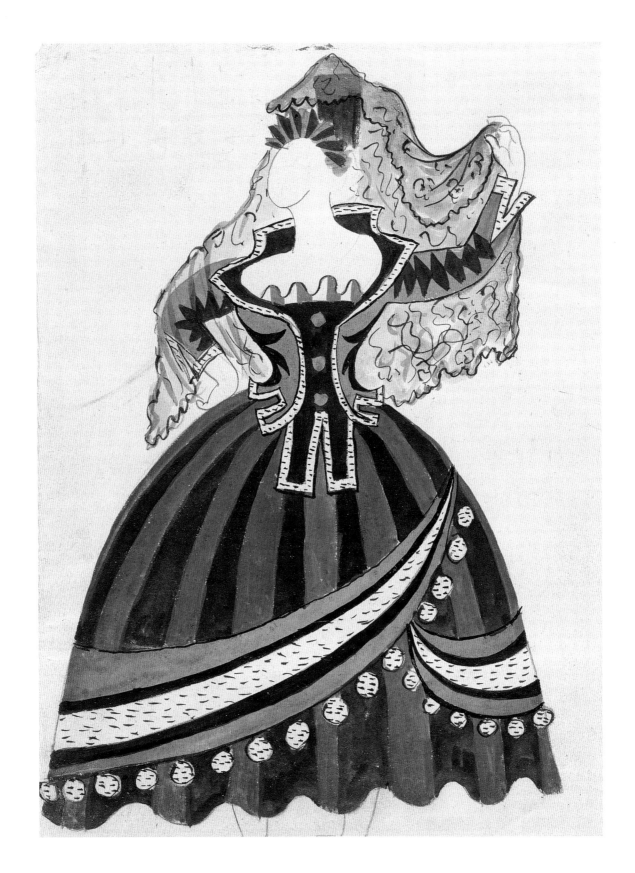

Pablo Picasso - Costume design for a Woman In: Le Tricorne, 1919

MUSÉE PICASSO, PARIS

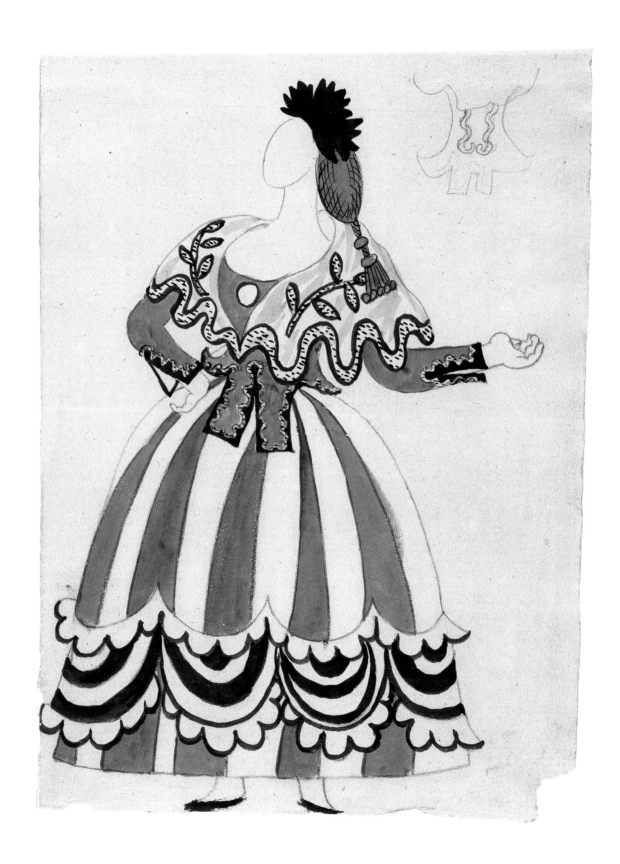

Pablo Picasso - Costume design for a Neighbour In: Le Tricorne, 1919
MUSÉE PICASSO, PARIS

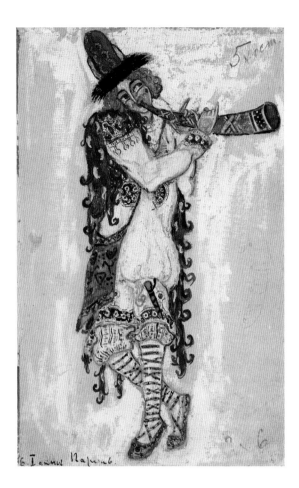

Nikolai Roerich - Costume design for a Youth
In: Le Sacre du printemps, 1913
STATE CENTRAL THEATRE MUSEUM A. A. BAKHRUSHIN, MOSCOW

Nikolai Roerich - Costume design for a Girl
In: Le Sacre du printemps, 1913
STATE CENTRAL THEATRE MUSEUM A. A. BAKHRUSHIN, MOSCOW

Nikolai Roerich - Costume design for a Man of the people In: Le Sacre du printemps, 1913

STATE CENTRAL THEATRE MUSEUM A.A. BAKHRUSHIN, MOSCOW

COSTUMES

The many sumptuous and extravagant costumes produced for the Ballets Russes testify to the fact that dance and movement were not always the principal focus of the performance. First and foremost, Diaghilev's ballet productions were visual spectacles in which the sculptural and static forms of the costumes featured prominently. It must have been extremely demanding to dance in such Bakst-designed costumes as the Chief Eunuch in *Schéhérazade* (1910; cat. 202), and there was little point in performing brilliant *jetés* in a gown as lavishly ruched as the one that Chiarina wore in *Carnaval* (1910; cat. 201). Only the most important dancers – such as Nijinsky in *Le Dieu bleu* (1912; cat. 204) – performed in costumes that revealed the contours of their moving bodies.

The costumes were made with extreme care: fabrics, for instance, were dyed by hand to ensure that they precisely matched the colours of the designs. After the First World War, however, financial constraints led to a diminution in the quality of the fabrics and the needlework.

Gontcharova and Larionov introduced an avant-garde aesthetic to the Ballets Russes in the years after 1914 – something that had already been seen on Moscow stages since 1910 courtesy, among others, of Kazimir Malevich. Although the penchant for exuberant costumes is still apparent in *Le Coq d'or* (1914), the colour combinations are bolder, for example in King Dodon's costume (cat. 218). The costume for one of the king's female subjects (cat. 219), by contrast, clearly displays the simplified geometrical forms of the Moscow avant-garde. The dancers in the ballet *Chout* (1921) seem to have been reduced more than ever to moving sculptures, while Larionov's Constructivist design of a buffoon's or a soldier's costume seems to preclude any possibility of dancing (cat. 220, 222).

The extravagance of the Russian designs contrasts with the simplicity of Henri Matisse's costumes for *Le Chant du rossignol* (1920). The monumental mourner's costume (cat. 225) is made out of white felt, with black triangles appliquéd onto it, while for the mandarin (cat. 226) Matisse painted simple flowers onto bright yellow silk.

Bakst returned to the Ballets Russes one last time in 1921 to produce the costumes for *The Sleeping Princess*. It was to be Diaghilev's most exuberant production ever, with dozens of handmade and extremely sumptuous costumes (cat. 209–12). The latter years of the Ballets Russes were characterized by continuing artistic innovation but worsening finances. One final highlight was the ballet *Le Bal* (1929), featuring eccentric costumes designed by Giorgio De Chirico (cat. 213–16).

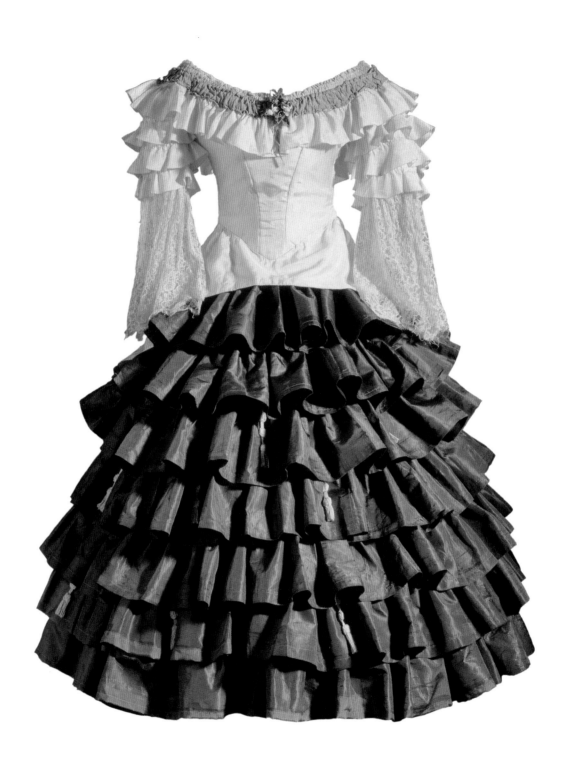

◄201►
Léon Bakst - Costume for Chiarina In: Carnaval, 1910
NATIONAL GALLERY OF AUSTRALIA, CANBERRA

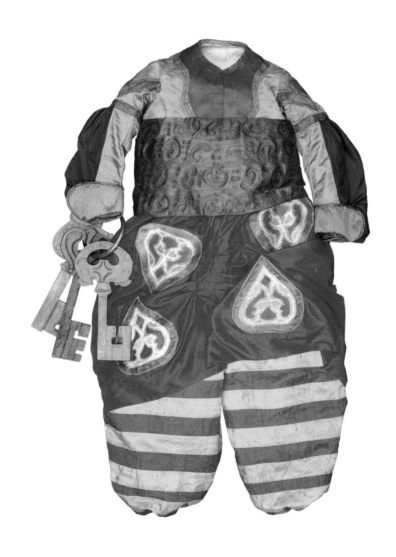

Léon Bakst - Costume for a Chief Eunuch In: Schéhérazade, 1910
NATIONAL GALLERY OF AUSTRALIA, CANBERRA

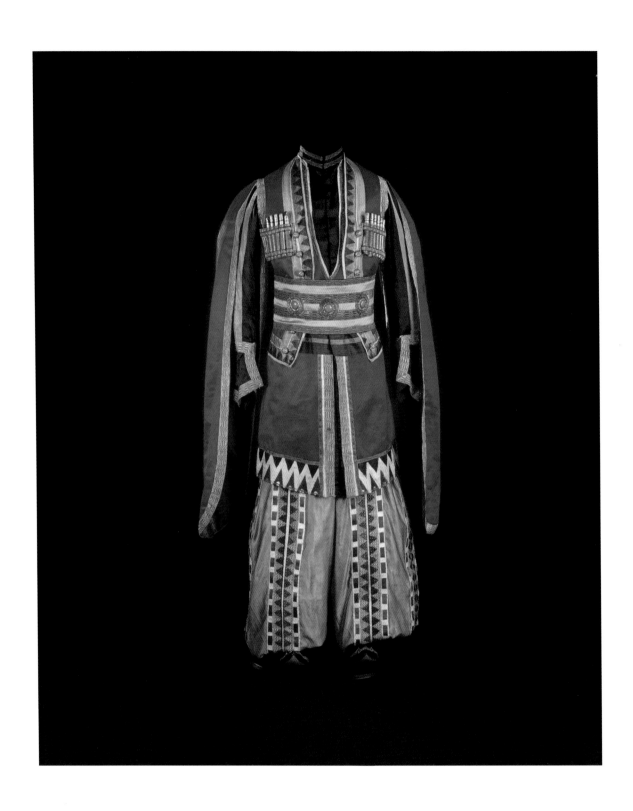

Léon Bakst - Costume for a Lezghin In: Thamar, 1912

NATIONAL GALLERY OF AUSTRALIA, CANBERRA

Léon Bakst - Costume for the Blue God In: Le Dieu bleu, 1912
NATIONAL GALLERY OF AUSTRALIA, CANBERRA

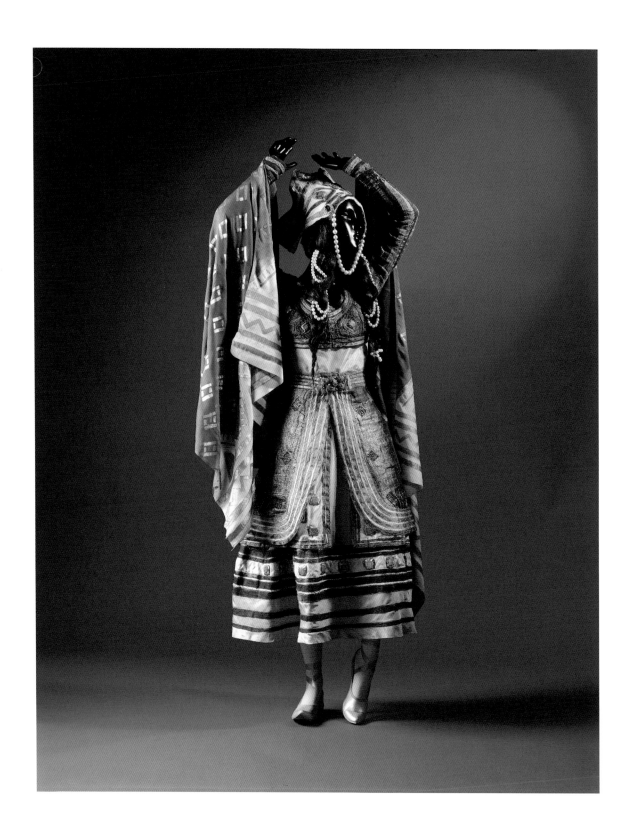

⤙205⤚
Léon Bakst - Costume for Queen Thamar In: Thamar, 1912
NATIONAL GALLERY OF AUSTRALIA, CANBERRA

+206+ +207+ +208+
Léon Bakst - Costumes for Nymphs In: L'Après-midi d'un faune, 1912

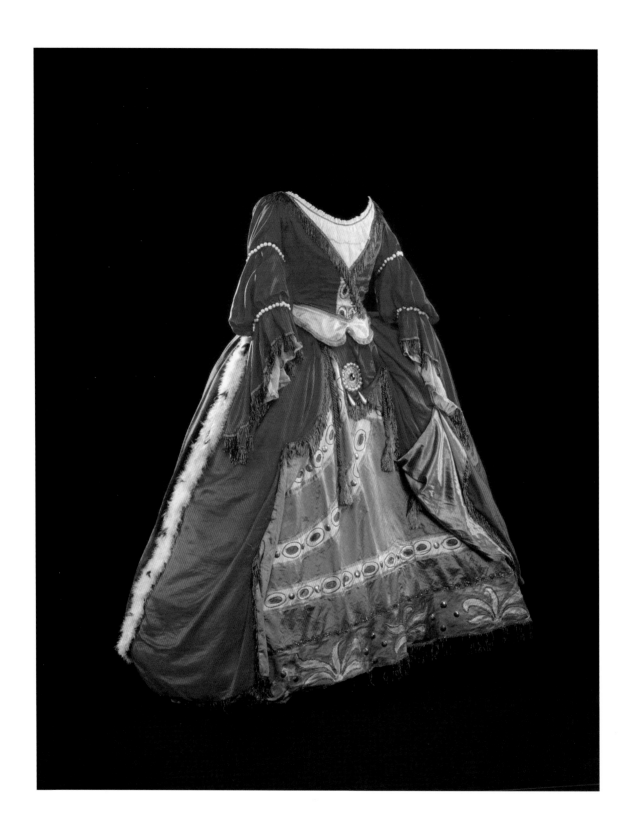

◄209►
Léon Bakst - Costume for a Lady-in-Waiting In: The Sleeping Princess, 1921
NATIONAL GALLERY OF AUSTRALIA, CANBERRA

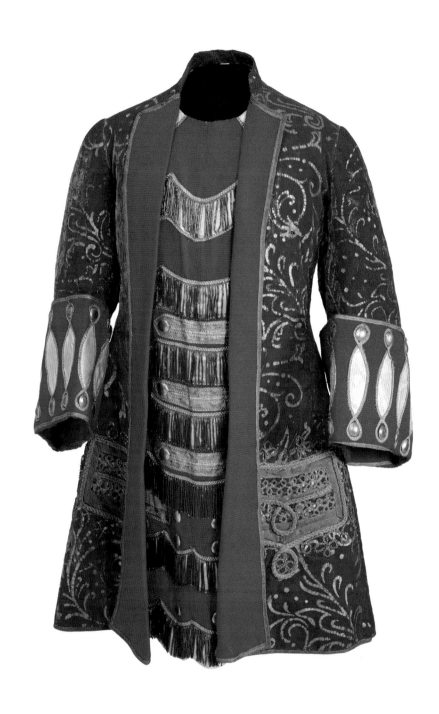

◄210►
Léon Bakst - Costume for the English Prince In: The Sleeping Princess, 1921
VICTORIA & ALBERT MUSEUM / THEATRE MUSEUM, LONDON

235

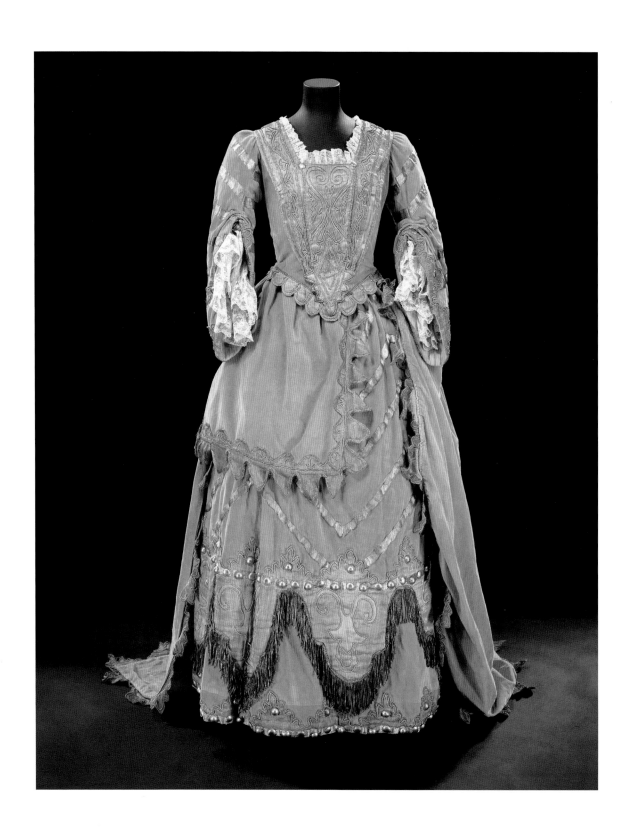

→211←
Léon Bakst - Costume for a Lady-in-Waiting In: The Sleeping Princess, 1921

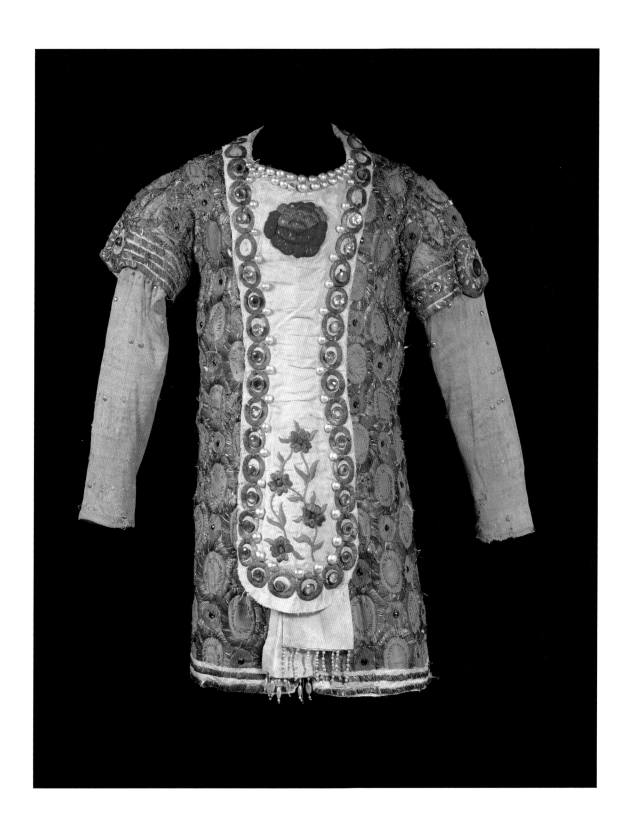

Léon Bakst - Costume for the Bluebird In: The Sleeping Princess, 1921

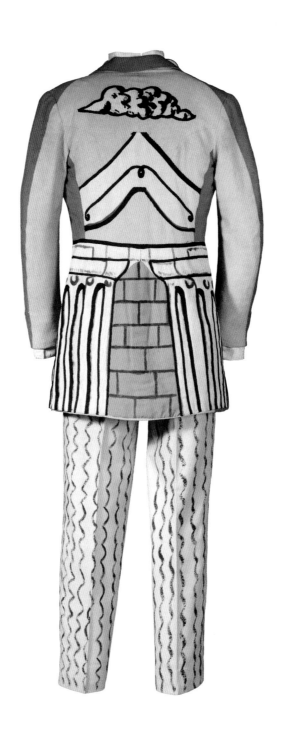

Giorgio De Chirico - Costume for a Male Guest In: Le Bal, 1929

NATIONAL GALLERY OF AUSTRALIA, CANBERRA

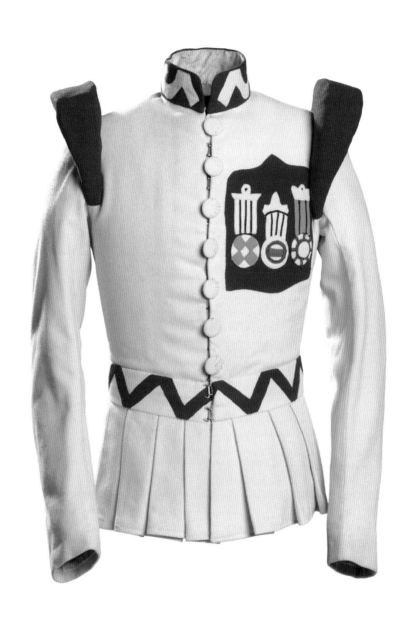

← 214 →
Giorgio De Chirico - Jacket for a Young Man In: Le Bal, 1929
NATIONAL GALLERY OF AUSTRALIA, CANBERRA

239

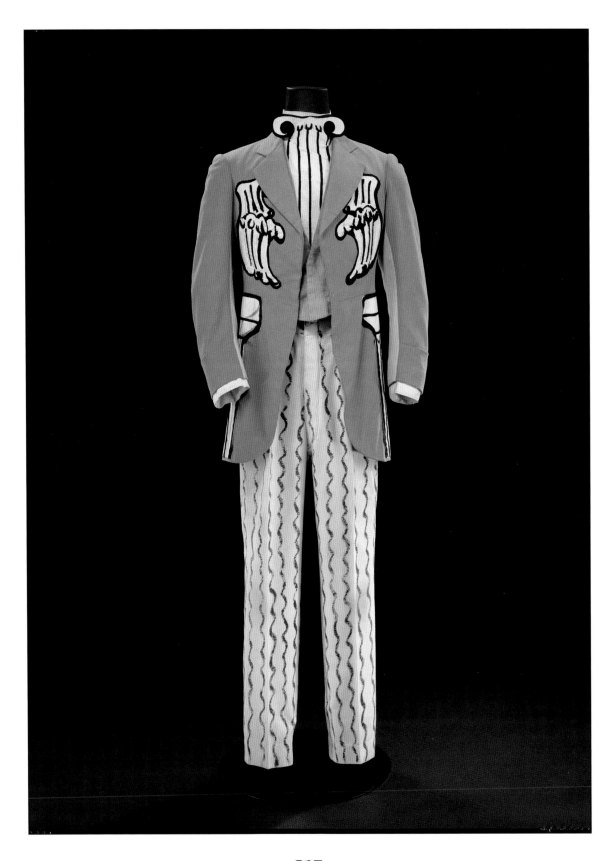

Giorgio De Chirico - Costume for a Guest In: Le Bal, 1929
VICTORIA & ALBERT MUSEUM / THEATRE MUSEUM, LONDON

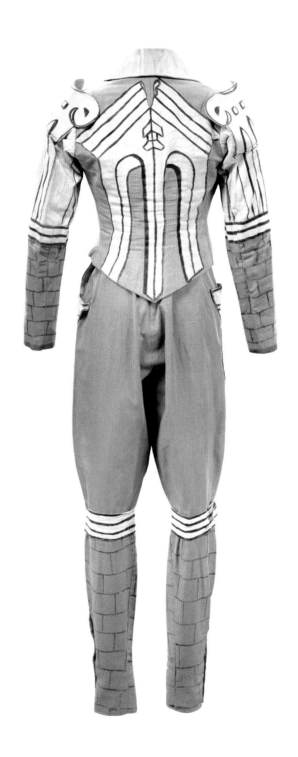

Giorgio De Chirico - Costume for a Guest In: Le Bal, 1929

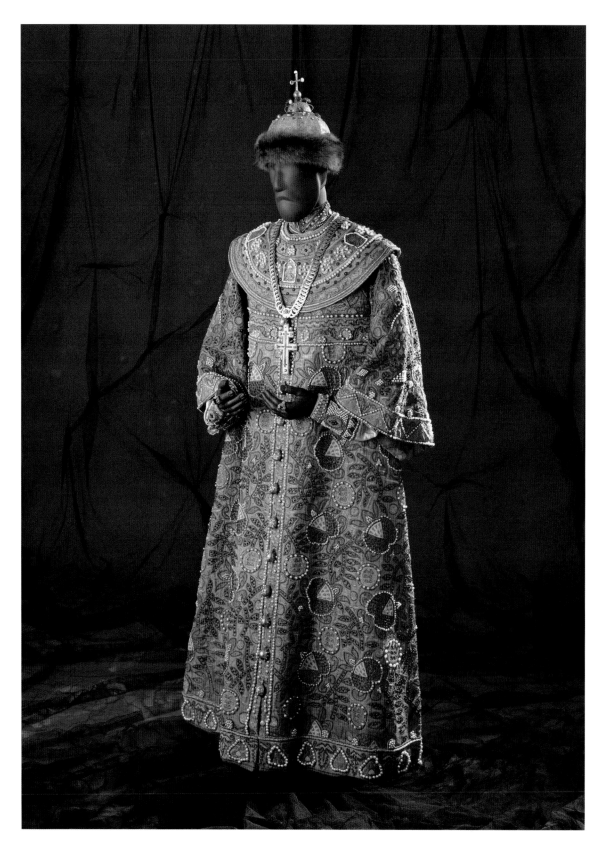

◄217►
Alexander Golovin - Costume for Boris In: Boris Godunov, 1913

VICTORIA & ALBERT MUSEUM / THEATRE MUSEUM, LONDON

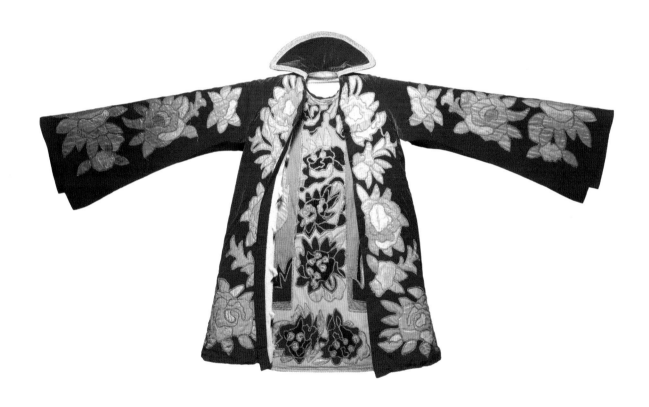

Natalia Gontcharova - Costume for King Dodon In: Le Coq d'or, 1937

NATIONAL GALLERY OF AUSTRALIA, CANBERRA

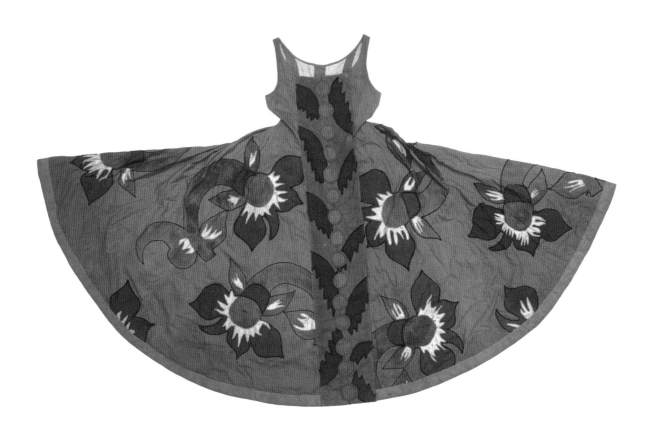

Natalia Gontcharova - Costume for a Female Subject of King Dodon In: Le Coq d'or, 1937

NATIONAL GALLERY OF AUSTRALIA, CANBERRA

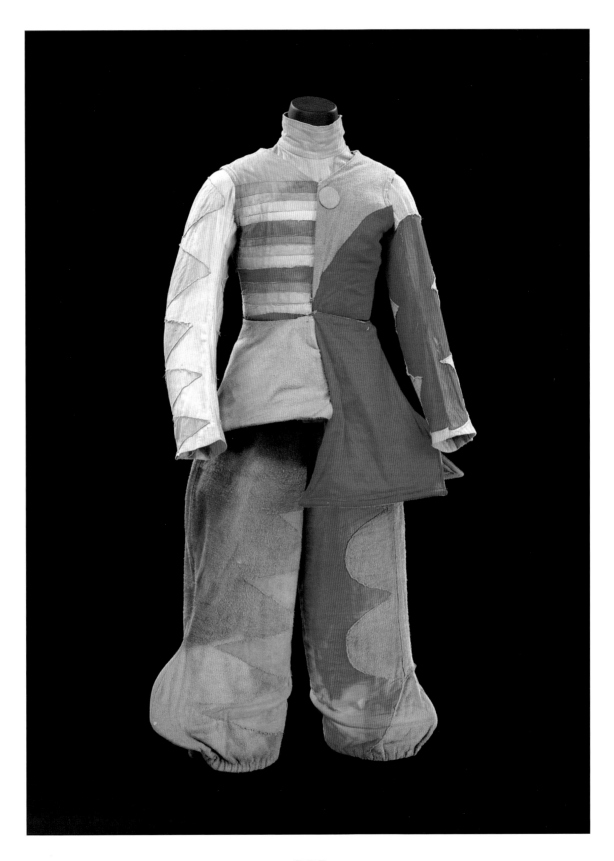

Mikhail Larionov - Costume for a Buffoon 1915. In: Chout, 1921

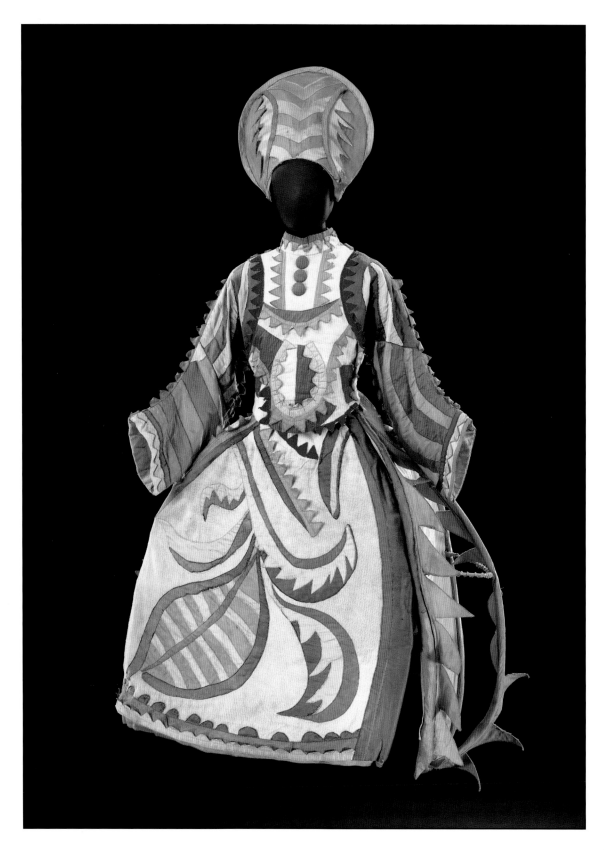

Mikhail Larionov - Costume for the Buffoon's Wife 1915. In: Chout, 1921

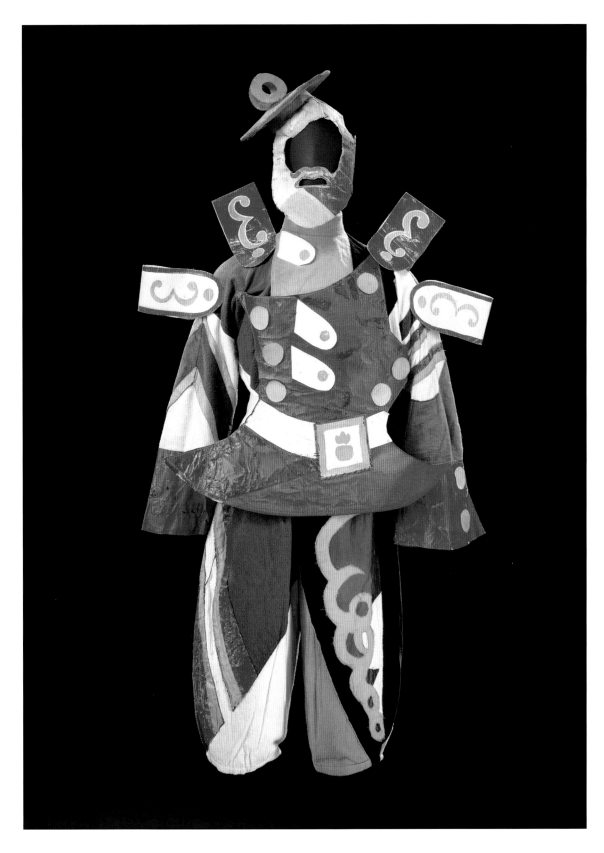

Mikhail Larionov - Costume for a Soldier 1915. In: Chout, 1921

VICTORIA & ALBERT MUSEUM / THEATRE MUSEUM, LONDON

+223+
Mikhail Larionov - Costume for the Snow Maiden In: Soleil de nuit, 1915
VICTORIA & ALBERT MUSEUM / THEATRE MUSEUM, LONDON

→224←
Henri Matisse - Costume for a Lady-in-Waiting In: Le Chant du rossignol, 1920
NATIONAL GALLERY OF AUSTRALIA, CANBERRA

249

Henri Matisse - Costume for a Mourner In: Le Chant du rossignol, 1920

NATIONAL GALLERY OF AUSTRALIA, CANBERRA

Henri Matisse - Costume for a Mandarin In: Le Chant du rossignol, 1920
VICTORIA & ALBERT MUSEUM / THEATRE MUSEUM, LONDON

Nikolai Roerich - Costume for Le Sacre du printemps 1913

VICTORIA & ALBERT MUSEUM / THEATRE MUSEUM, LONDON

◄228►
Nikolai Roerich - Costume for Le Sacre du printemps 1913
VICTORIA & ALBERT MUSEUM / THEATRE MUSEUM, LONDON

←229→
Nikolai Roerich - Costume for Le Sacre du printemps 1913
VICTORIA & ALBERT MUSEUM / THEATRE MUSEUM, LONDON

254